REMBRANDT'S
POLISH RIDER

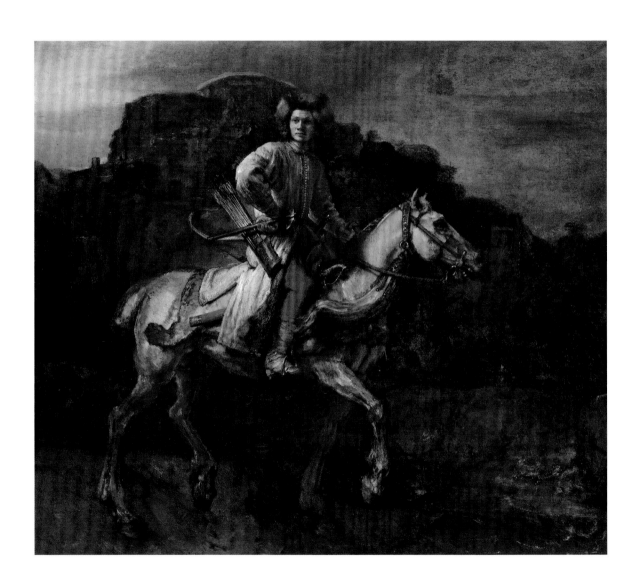

REMBRANDT'S POLISH RIDER

Maira Kalman
Xavier F. Salomon

The Frick Collection, New York
in association with D Giles Limited

g

FRICK DIPTYCH SERIES

Designed to foster critical engagement and interest the specialist and non-specialist alike, each book in this series illuminates a single work in the Frick's rich collection with an essay by a Frick curator paired with a contribution from a contemporary artist or writer.

This publication is supported in part by Furthermore: A program of the J. M. Kaplan Fund.

Furthermore:
a program of the J. M. Kaplan Fund

First published in 2019 by The Frick Collection
1 East 70th Street
New York, NY 10021
www.frick.org

Michaelyn Mitchell, Editor in Chief
Christopher Snow Hopkins, Assistant Editor

In association with GILES
An imprint of D Giles Limited
66 High Street
Lewes, BN7 1XG, UK
gilesltd.com

Copyedited and proofread by Sarah Kane
Designed by Caroline and Roger Hillier,
The Old Chapel Graphic Design

Typeset in Garamond
Produced by GILES
Printed and bound in China

Cataloguing-in-Publication Data is available from the Library of Congress

ISBN 978-1-911282-53-2

Cover and p. 22: Rembrandt van Rijn, details of *The Polish Rider*, ca. 1655 (frontispiece)
Frontispiece: Rembrandt van Rijn, *The Polish Rider*, ca. 1655. Oil on canvas, 46 × 53⅛ in. (116.8 × 134.9 cm). The Frick Collection, New York
Page 6: *The Polish Rider* in the Frick's West Gallery

CONTENTS

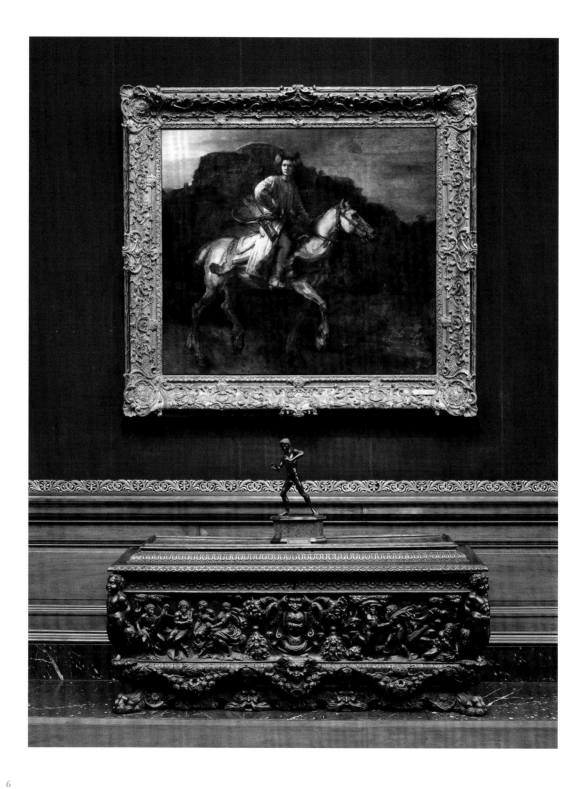

DIRECTOR'S FOREWORD

Looking toward the Polish Rider she met his calm tender gentle thoughtful gaze. She thought, what he sees is the face of death. He sees the silence of the valley, its emptiness, its innocence—and beyond it the hideous field of war on which he will die. And his poor horse will die too. He is courage, he is love, he loves what is good, and will die for it, his body will be trampled by horses' hooves, and no one will know his grave. She thought, he is so beautiful, he has the beauty of goodness.

—Iris Murdoch, *The Green Knight*, 1995

Numerous captivating narratives, both literary and scholarly, have been imposed on the romantic figure in *The Polish Rider*, the great Rembrandt canvas that has been on view at the Frick since the museum opened. For centuries, this much loved painting has been puzzled over and theorized about. But while the question of its attribution to Rembandt has been settled to the satisfaction of most scholars, we may never have all the answers regarding its subject and provenance. Xavier F. Salomon, the Frick's Peter Jay Sharp Chief Curator, has, however, contributed mightily—in this fourth book in our Diptych series— to the ongoing critical discourse. And alongside Xavier's incisive essay is Maira Kalman's enchanting flight of fancy. Our deep appreciation goes to them both for adding their unique perspectives to this great work of art and thereby enriching our understanding and appreciation of it.

Others at the Frick to whom gratitude is extended include Emma Holter, Administrative Assistant; Genevra Le Voci, Head of Leadership Gifts; Alexis Light, Senior Manager of Media Relations and Marketing; and Jenna Nugent, former Executive Assistant to the Chief Curator; as well as to Editor in Chief Michaelyn Mitchell, who managed the production of the publication and, with Assistant Editor Christopher Hopkins and then Associate Editor Hilary Becker, edited the texts. We would also like to acknowledge our longtime publishing partner, D Giles Limited. And finally, we would like to thank Furthermore, a program of the J.M. Kaplan Fund, for its generosity in providing partial support for this publication.

Ian Wardropper
Anna-Maria and Stephen Kellen Director, The Frick Collection

ACKNOWLEDGMENTS

I would like to thank Rembrandt and all the painters in the Frick for doing their work and not giving up. And I would dearly like to thank Michaelyn Mitchell, Xavier Salomon, and Ian Wardropper for so kindly inviting me into their world and allowing me to die at the Frick.

Maira Kalman

This book would not have been possible without the encouragement and help of numerous people. Ian Wardropper and the trustees of The Frick Collection have been supportive at every stage. I would also like to thank Michaelyn Mitchell for her impeccable editing and comments, as well as Christopher Snow Hopkins, Hilary Becker, Emma Holter, and Serena Rattazzi. As always, Jenna Nugent, my former assistant, was involved with this project every step of the way; my heartfelt thanks go to her. Aleksander M. Musial, during his internship at the Frick, helped with some research for this book. I am grateful to Pieter Roelofs at the Rijksmuseum in Amsterdam for many conversations about Rembrandt and to Mathieu Deldicque, with whom I shared a trip to California to look at and discuss the painter's copies of Mughal miniatures. I would also like to thank Charlotte Rulkens, in Amsterdam. Special thanks to Sarah McNear for bringing Frank O'Hara into the life of The Frick Collection. Emma Capron, Adam Eaker, Margaret Iacono, and Joanna Sheers Seidenstein read drafts of my essay and made useful comments. All errors, of course, are mine.

In the course of my research, it was a particular pleasure to travel around Poland, in August 2018, and meet with a number of colleagues to discuss Rembrandt's *Polish Rider*. In Warsaw, Ewa Manikowska at the Polish Academy of Sciences, Institute of Art, and Marta Zdańkowska at the Royal Castle helped with numerous queries and provided valuable information about the painting and its life in Poland. Izabela Zychowicz at the Royal Łazienki Museum in Warsaw and Tadeusz Zych at Dzików Castle assisted me at their respective institutions. Adam Zamoysky and Emma Sergeant were the perfect hosts in the Polish countryside; it was a pleasure to spend an evening with them talking about Polish history—particularly in the company of three unexpected Polish riders. My greatest thanks go to two extraordinary people

I was lucky to encounter during my Polish summer. Dorota Juszczak, with whom I crossed paths many years ago when I was working at Dulwich Picture Gallery, provided valuable comments and much unpublished material from her research. She has improved this book with her expertise, intelligence, and grace, and for that, and for her generosity and friendship, I owe her a great debt of gratitude. Michał Przygoda has also accompanied me through this project and beyond. Our almost daily exchanges about *The Polish Rider*, about frames and costumes, orangeries and collectors, have offered some of the most wonderful moments during this research project. He has also helped with many queries, as I attempted to come to grips with Polish history, culture, and language. I could not have written this book without Dorota and Michał— *Dziękuję bardzo!*

It has been an honor, as well as great fun, to collaborate with the brilliant Maira Kalman.

I would like to acknowledge the Tarnowski family for allowing me to study a large volume of material related to their family history. Jaś "Głowa" and Marychna kindly welcomed me to their home in Wilanów and shared memories and papers with me. My lunch at their house with three generations of the family—Rosabelle, Zosia, Andrew and Stefan Tarnowski, and Charlie Trafford—will always be a treasured memory. Another unforgettable day was the visit to Dzików Castle with Rosabelle, Andrew, and Stefan. I would like to especially thank Andrew for teaching me the value of looking at a historical subject with both detachment and sympathy.

Finally, this book is dedicated to Stefan Tarnowski and Victoria Lupton, with boundless admiration.

Xavier F. Salomon
Peter Jay Sharp Chief Curator, The Frick Collection

by Maira Kalman

Poor Rembrandt

It drives me crazy that
he died a pauper.
Buried in a pauper's grave.
Debts. Worries. Sorrows.
Not a good end.
But then, what is a good end?
Let's not dwell on that.
What else do we know?

HE LIVED HERE.

HE SLEPT HERE.

HE MARRIED
THE BEAUTIFUL SASKIA
WHO DIED AT THE
AGE OF 29.

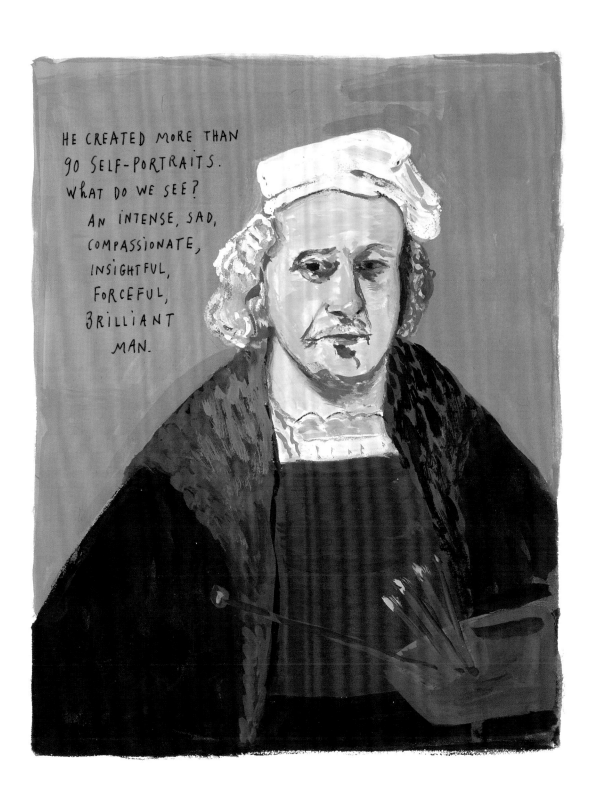

HE CREATED MORE THAN
90 SELF-PORTRAITS.
WHAT DO WE SEE?
AN INTENSE, SAD,
COMPASSIONATE,
INSIGHTFUL,
FORCEFUL,
BRILLIANT
MAN.

AND WHAT OF THE POLISH RIDER AND THE
POLISH CONNECTION? A BIG MYSTERY.
THERE ARE MANY QUESTIONS.
WHY ARE THE HORSE'S LEGS SO AWKWARD?
AND WHAT ABOUT THE HANDS? IS THAT
THE BEST HE COULD DO?
LET'S LEAVE THAT ASIDE. WE KNOW FOR A FACT,
OR CONJECTURE, THAT REMBRANDT ATE BREAD
MADE FROM POLISH WHEAT. A VISITING
TRADER FROM POLAND MAY HAVE SOLD him
OLD COSTUMES THAT TICKLED his FANCY.
AND WHAT OF OTHER POLISH CONNECTIONS?

CHOPIN LEAPS TO MIND. HE TOO HAD A BAD END. DYING SO YOUNG. RED BLOOD SPLATTERED ON THE WHITE PIANO KEYS. BUT AGAIN, WHAT IS A GOOD END? MYSTERIES ABOUND HERE AS WELL. WHY WAS HIS RELATIONSHIP WITH GEORGE SAND SO DIFFICULT?

So Now

WE HAVE DISCUSSED LIFE. DEATH. LOVE. MONEY.

SORROW. MUSIC. ART.

THAT PRETTY MUCH COVERS EVERYTHING.

A FEW WORDS ABOUT THE FRICK

BEFORE WE SAY GOODBYE.

VELVET. ACRES OF VELVET.

A THICK, RICH HUSH.

A GREEN SOFA THAT NEVER STOPS
BEING FASCINATING.

AND OH YES, THE PAINTINGS.

TO DIE FOR.

TO DIE IN THE FRICK.

THAT WOULD BE A GOOD END.

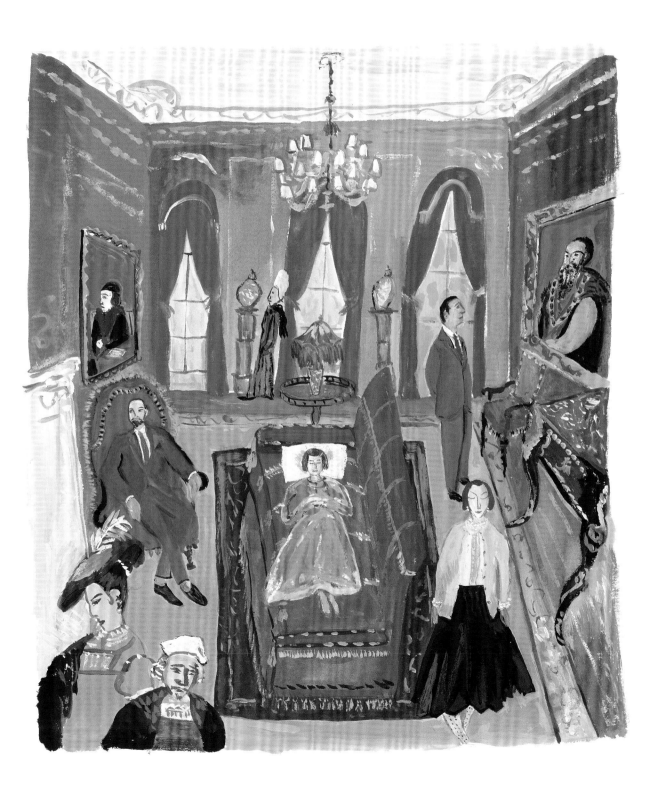

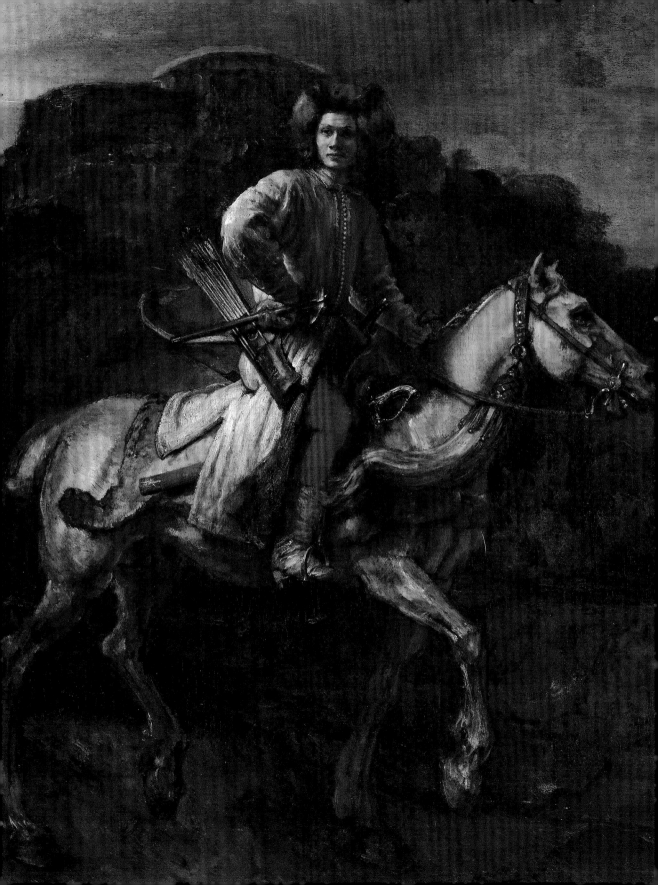

REMBRANDT'S POLISH RIDER

Xavier F. Salomon

I look at you and I would rather look at you than all the portraits in the world except possibly for the *Polish Rider* occasionally and anyway it's in the Frick which thank heavens you haven't gone to yet so we can go together the first time . . .
—Frank O'Hara (1926–1966), 1960

Frank O'Hara included these lines in one of his most lyrical poems, "Having a Coke with You," written for his lover, the dancer Vincent Warren, in 1960, and published in *Lunch Poems* five years later. In the painting referred to, a handsome young man on horseback rides across shadowy lands toward the unknown. Atop a rocky hill, a peculiar domed building looms over the figure, and other buildings seem to climb the hill. A waterfall may be on the left. A body of water—a river or a lake—divides the path between rider and town. A small fire burns on the opposite shore, and a few tiny figures gather around it. The rider sits purposefully on a gray-white horse richly adorned with a red bridle, gilt decoration, and a leopard skin over its back. Though emaciated, the animal has a certain nobility as it marches forward. The youth, dressed in red trousers and a white coat, conveys a similar sense of resolve, melancholy, and sophistication. He wears yellow leather boots and a vermilion cap decorated with fur and is armed with two sabers—one at his left side, the other under his right thigh—and a bow (at his left) and quiver crammed with arrows (at his right). With his left hand, he holds the reins; with his right, he flaunts a war hammer, his elbow projecting into the viewer's space. While trooping forward, the rider turns as if to look back.

The painter captures this movement, shaping the head in a tense boundary between shadow and light.

The work Frank O'Hara adored is the painting known as *The Polish Rider* by Rembrandt van Rijn (fig. 1), and it has been on view at The Frick Collection since the museum opened to the public in December 1935. O'Hara is one of many writers to have been inspired by the canvas. In 1939, Marguerite Yourcenar (1903–1987) referenced the painting in *Coup de Grâce*, a short novel set during World War I in Livonia and Kurland. Based on a true story, *Coup de Grâce* is the self-portrait of a soldier, Erick von Lhomond, and of his relationships with his boyhood friend Conrad de Reval and Conrad's sister Sophie. Following an attack by the Cossacks on Erick's and Conrad's squadron near the village of Novogrodno—"towards evening the last of the enemy horse disappeared, crossing the rye fields, but Conrad, shot in the belly, lay dying"—Erick recalls:

> when I think of those last days of my friend's life I evoke, almost automatically, a picture of Rembrandt's not widely known, in the Frick Gallery of New York. I discovered it by chance on a morning of snow-storm when I had nothing else to do, and the impression it made upon me was that of a ghost who had acquired an accession number and a place in the catalogue: that youth, mounted on a pale horse, half turning in his saddle as he rides swiftly on, his face both sensitive and fierce, a desolate landscape where the nervous animal seems to sense disaster ahead, and Death and the Devil infinitely more in attendance there than in Dürer's engraving.[1]

Yourcenar's drawing of a direct visual link between Rembrandt's rider and the knight in armor in Albrecht Dürer's celebrated print *Knight, Death, and the Devil* (fig. 2) would be taken up by art historians of the subsequent generations. The writer Iris Murdoch (1919–1999) is also known to have visited the Frick a number of times to admire *The Polish Rider*.[2] The American curator and collector Sam Wagstaff (1921–1987) is said to have claimed that of all the figures he had seen in paintings, the one he would have most liked to be was the youth in *The Polish Rider* (no doubt this had something to do with Wagstaff's Polish ancestry).[3] Artists have also long admired Rembrandt's painting. In 1910, Walter Sickert (1860–1942) saw the canvas in London and declared it "one of the perfect masterpieces of the world."[4] About 1917–18, the young Alberto Giacometti (1901–1966) copied *The Polish Rider*

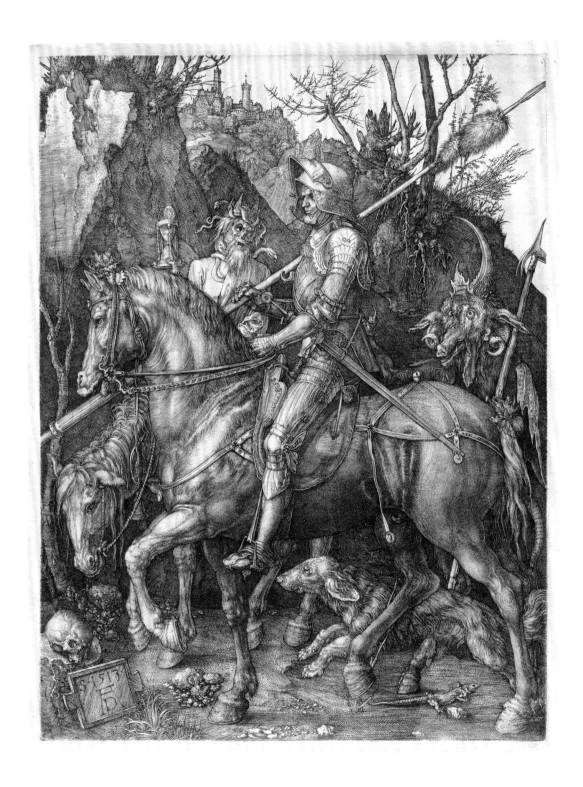

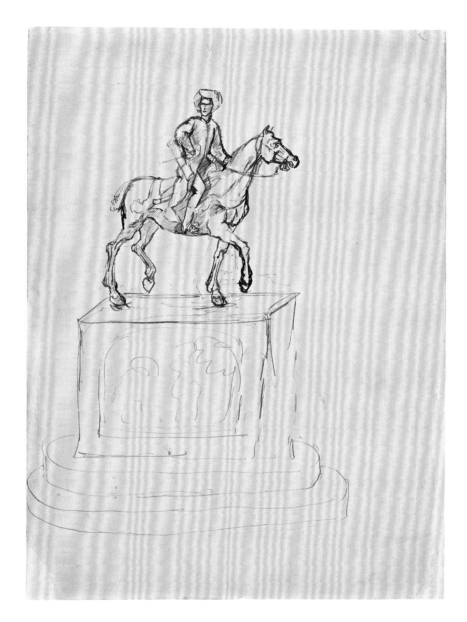

Fig. 3
Alberto Giacometti
*Rembrandt's "The Polish Rider"
as Monument*, ca. 1917–18
Pen and purple ink on paper
13¼ × 9⅞ in. (335 × 252 mm)
Kunsthaus Zürich, Alberto
Giacometti-Stiftung

from a black-and-white reproduction and transformed it into an equestrian monument (fig. 3).

The Polish Rider was revered by intellectuals and artists in the first half of the twentieth century; however, in the last thirty-five years, the painting, more specifically its attribution, has been the subject of a complex and well-publicized controversy. In 1906, Alfred von Wurzbach was the first

art historian to doubt Rembrandt's authorship of the canvas. He attributed the painting to Rembrandt's pupil Aert de Gelder (1645–1727) but four years later reattributed it to the master.[5] In 1968, seven art historians from the Netherlands established the Rembrandt Research Project (RRP), with the goal of creating the definitive catalogue of the painter's work. Initially chaired by Josua Bruyn, the RRP was later headed by Ernst van de Wetering.[6] Using careful connoisseurship and cutting-edge technical analysis, the RRP examined more than four hundred paintings by or attributed to Rembrandt; their results were published in a series of six volumes between 1982 and 2014.

In a book review in a 1984 issue of *Oud Holland*, Josua Bruyn mentioned, in passing, his belief that *The Polish Rider* showed "striking affinities" to the early work of Rembrandt's pupil Willem Drost (1633–1659).[7] The comment struck the art world like a thunderbolt and became a *cause célèbre* in the 1990s. Many were incensed by Bruyn's assertions, and, even though the RRP never officially demoted *The Polish Rider*, a number of articles were written in defense of Rembrandt's authorship of the painting.[8] By the time the RRP published their official findings on the painting, Jonathan Bikker had already forcefully rejected, in his monograph on Willem Drost, an attribution to him.[9] Van de Wetering said that the RRP had concluded that the painting was by Rembrandt. He did, however, propose that portions of the canvas— parts of the horse, such as its hindquarters, tail, and legs, the rider's hands, and areas of the landscape—may have been left unfinished by Rembrandt and that other minor sections—the shank of the boot and the folded-back tail of the coat—may have been completed by another hand at a later stage.[10]

Bruyn's doubts notwithstanding, the authorship of *The Polish Rider* has been returned to Rembrandt in the fifth and sixth installments of the RRP's Rembrandt *Corpus*.[11] Aspects of its physical condition, however, make certain analyses difficult. Both the height and width of the painting have been altered. The right edge has been cut, and Rembrandt's signature has been reduced, with only the "R" (and possibly an "e") now visible on the rock at bottom right. A strip of about four inches at the bottom has been added to the painting, presumably to replace the damaged lower part of the canvas.[12] This means that the hooves and lower parts of the horse's front left and back right legs, as well as the ground on which they stand, have been repainted by a subsequent restorer. Therefore, the uneasy way the horse stands is the result of later interventions. We know that *The Polish Rider* was restored more than once in modern times:

probably in Vienna in 1833 and again in 1877. It was then cleaned by Alois Hauser, in Berlin, in 1898 and lastly by William Suhr, in New York, in 1950.[13] Notwithstanding its recent attribution vicissitudes and complicated physical condition, one cannot help but agree with the art historian Kenneth Clark, who described the painting as "one of the great poems of painting" and "the most personal and mysterious of his [Rembrandt's] later paintings."[14]

The House on the Breestraat: Amsterdam, ca. 1655

Rembrandt Harmenszoon van Rijn (1606–1669) was born in Leiden on July 15, 1606, to Harmen Gerritsz. van Rijn,[15] a miller, and Cornelia Willemsdr. van Zuytbrouck, the daughter of a wealthy baker. As a young man, Rembrandt apprenticed with the local painter Jacob van Swanenburgh (1571–1638) for approximately three years and then, about 1625, in Amsterdam under Pieter Lastman (1583–1633) for six months. Between 1625 and 1631, he established his workshop in Leiden, in partnership with another painter, Jan Lievens (1607–1674). During this period, he produced small and medium-sized paintings, most representing biblical, mythological, and historical scenes. At the end of 1631, he moved permanently to Amsterdam, where he lived with the art dealer Hendrick van Uylenburgh (1587–1661) for the first four years. Through Uylenburgh, he started working for the wealthy merchants of Amsterdam, producing his first full-scale portraits. On June 22, 1634, Rembrandt married Uylenburgh's cousin, Saskia. Between their wedding and Saskia's death, in 1642, the couple had four children, only one of whom— Titus (1641–1668)—survived longer than a few months. Rembrandt's success in Amsterdam allowed him to move out of Uylenburgh's household about 1635 and, in January 1639, to buy a large house on the Breestraat, next door to Uylenburgh. He purchased the house from Christoffel Thijs for the hefty price of thirteen thousand guilders.[16] Rembrandt's early biographers note his taste for expensive objects and curios: "for the rest, he was also a great lover of art in its various forms, such as pictures, drawings, engravings and all sorts of foreign curiosities of which he possessed a great number, displaying great enthusiasm about such things."[17] These were displayed in the house where Rembrandt also had a studio and ran his workshop. In 1686, the biographer Filippo Baldinucci recalled:

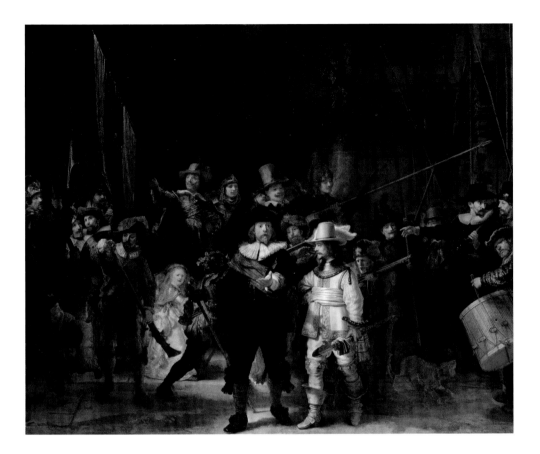

he often went to public sales by auction; and here he bought clothes that were old-fashioned and cast-off, as long as they struck him as bizarre and picturesque. Even though at times they were downright dirty, he hung them on the walls of his studio among the beautiful curiosities which he also took pleasure in owning. These included every kind of old and modern arms—arrows, halberds, daggers, sabers, knives and so on—and innumerable quantities of exquisite drawings, engravings and medals, and every other thing which he thought a painter might ever need.[18]

Fig. 4
Rembrandt van Rijn
The Militia Company of Frans Banning Cock (*The Night Watch*), 1642
Oil on canvas
149⅜ × 178½ in.
(379.5 × 453.5 cm)
Rijksmuseum, Amsterdam

The most prominent commission of Rembrandt's career came in 1641, when he was asked to paint a large militia company portrait for the new hall of the Kloveniersdoelen (the Company of Arquebusiers's headquarters). Completed in 1642, *The Militia Company of Frans Banning Cock*, known as *The Night Watch* (fig. 4), exemplifies the painter's artistic powers at a moment when his career was becoming well-established. It remains his best-known work.[19]

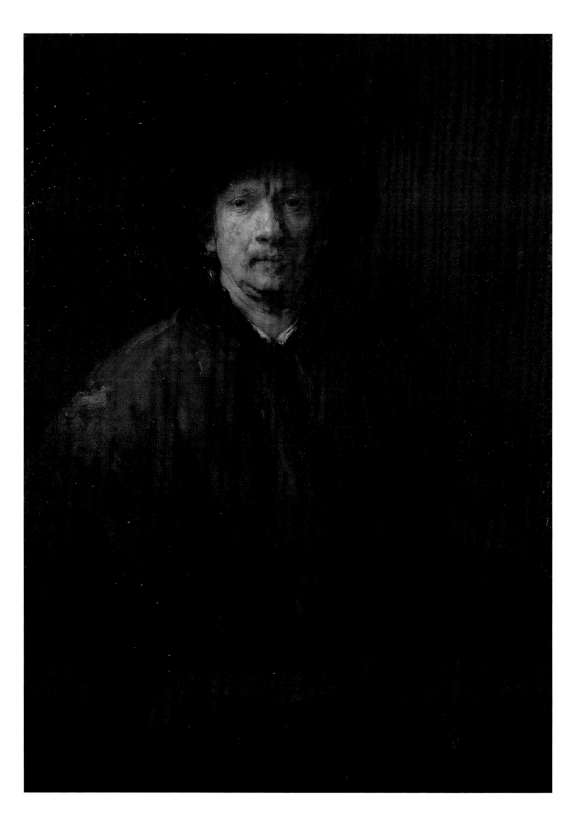

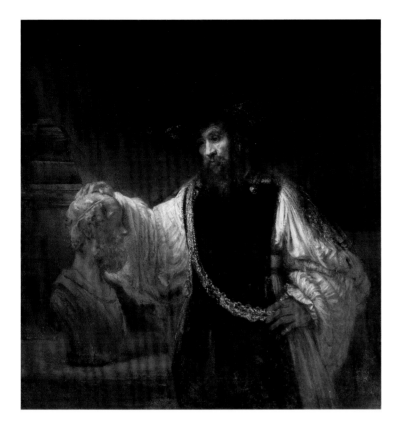

Fig. 5
Rembrandt van Rijn
Self-Portrait, 1652
Oil on canvas
44⅛ × 32⅛ in. (112 × 81.5 cm)
Kunsthistorisches Museum,
Vienna

Fig. 6
Rembrandt van Rijn
Aristotle with a Bust of Homer,
1653
Oil on canvas
56½ × 53¾ in.
(143.5 × 136.5 cm)
The Metropolitan Museum of
Art, New York

Rembrandt was a compulsive observer of his own features, producing more than ninety self-portraits between the 1620s and his death. In 1652, he portrayed himself as an accomplished painter proudly standing, both hands on his hips, confronting the viewer with his searching gaze (fig. 5). In the 1650s, Amsterdam was a city of two hundred thousand people, the bustling cultural and artistic center of the Netherlands, and Rembrandt was its preeminent painter. The city's funds at the time were largely directed toward the building of a magnificent new city hall (now the Royal Palace) on the Dam Square, which was inaugurated in 1655.

In the mid-1650s, Rembrandt produced some of his most celebrated works. In 1653, he painted *Aristotle with a Bust of Homer* (fig. 6), a large canvas made for the Sicilian aristocrat Antonio Ruffo. Rembrandt depicted the Greek philosopher resting his hand on a bust of the poet, woefully looking at it. The letters between patron and painter shed light on the subject; without them, it would be nearly impossible to identify the elegantly dressed, bearded

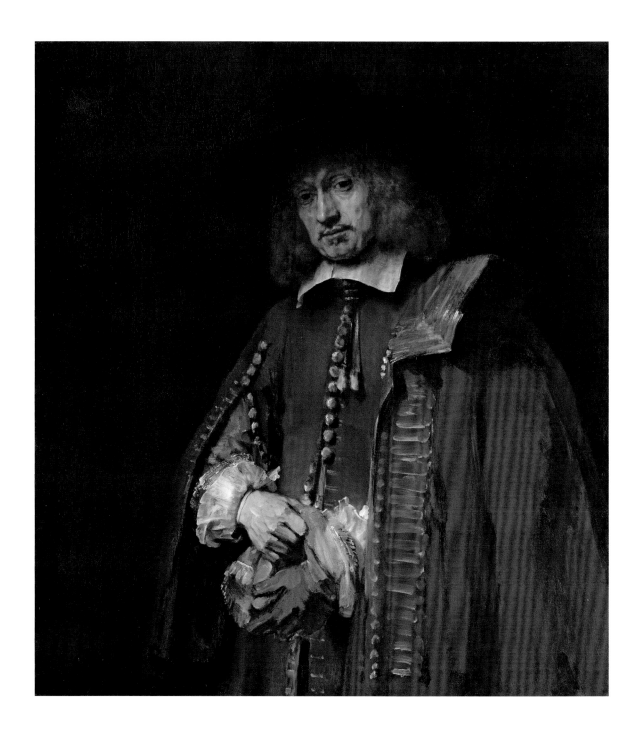

man, with his broad hat and gold chain, as Aristotle. A year later, in 1654, Rembrandt portrayed his close friend Jan Six (1618–1700) (fig. 7), in what is possibly the best of his portraits. Six emerges from the dark background in the act of removing a glove, his red cloak casually resting on his left shoulder. In the self-portrait of 1652, *Aristotle with a Bust of Homer*, and the portrait of Jan Six, Rembrandt approaches his subjects with broad and forceful brushwork, manipulating paint in astonishing ways.

While no document confirms the year of its making, *The Polish Rider* is traditionally dated about 1655—and therefore must have been painted in the studio of the house on the Breestraat—when Rembrandt was at the height of his career, as well as on the verge of some major changes.[20] After Saskia's death in 1642, Rembrandt had had a turbulent liaison with Titus's nurse, Geertje Dircx. Thereafter, he began a relationship with Hendrickje Stoffels, who would become his common-law wife and with whom he had a daughter, Cornelia, in 1654. That same year, Hendrickje was summoned before church officials for living in sin with the artist. Two years later, in 1656, Rembrandt declared bankruptcy and was dispossessed of his belongings, which were sold in a series of six auctions over a period of more than two years. This was the occasion for a complete inventory that was drafted on July 25 and 26 of 1656. In 1658, Rembrandt, Hendrickje, and the two children moved to a smaller rental in the Jordaan district. Even though he remained active as an artist, with prominent commissions, Rembrandt's fortunes never flourished again after the bankruptcy. His late years were overshadowed by the deaths of Hendrickje in 1663 and of Titus, who died of the plague in 1668. Rembrandt would die less than a year later, on October 4, 1669. He died a pauper and was buried in an unmarked grave in the Westerkerk.

The King's Orange Trees: Warsaw, 1791–98

The Polish Rider is not documented until 1791, about one hundred and thirty-six years after it was painted. No earlier mention of it survives.[21] In mid-August 1791, Stanisław August Poniatowski (1732–1798), King of Poland, received a letter from Michał Kazimierz Ogiński (1728–1800), Grand Hetman of Lithuania (fig. 8) and an art collector also known for his interests in music and science. Ogiński had been in The Hague for most of 1791, and it was probably after he had returned to Poland that he wrote this brief, witty letter to the king: "Sire, I am sending Your Majesty a Cossack, whom

Fig. 7
Rembrandt van Rijn
Jan Six, 1654
Oil on canvas
44⅛ × 40⅛ in. (112 × 102 cm)
Six Collection, Amsterdam

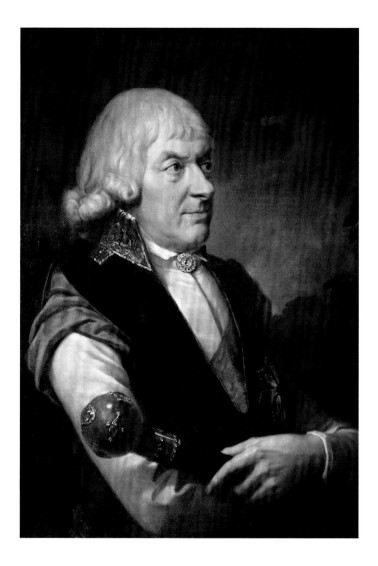

Fig. 8
Attributed to Józef Pitschmann
Michał Kazimierz Ogiński, 1793
Oil on canvas
30¾ × 21¼ in. (78 × 54 cm)
Muzeum Narodowe w
Warszawie, Warsaw

Reinbrand had set on his horse. This horse has eaten during his stay with me for 420 German gulden. Your Majesty's justice and generosity allows me to expect that orange trees will flower in the same proportion."[22] Ogiński did not indicate how he had procured the painting. And no mention is made of it in Ogiński's German letters. So while it cannot be ruled out that he acquired the painting in Germany, it is more likely he bought it in the Netherlands in the spring of 1791. It is also unclear whether Ogiński purchased the painting for himself or as a gift for the king. Stanisław August was known for his collection of potted orange trees, especially those at the Łazienki Palace, his residence

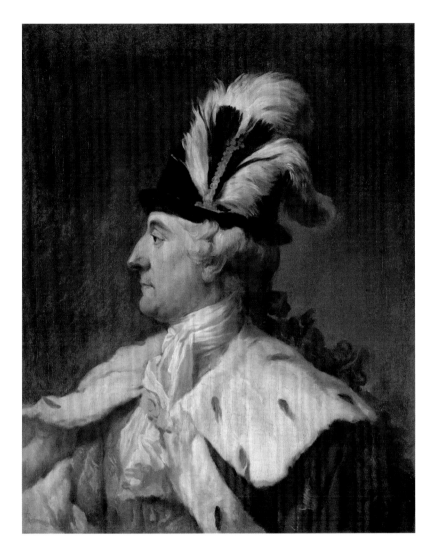

Fig. 9
Marcello Bacciarelli
King Stanisław August in a Feathered Hat, ca. 1785
Oil on canvas
28 × 22½ in. (71 × 57 cm)
Muzeum Narodowe w Warszawie, Warsaw

outside Warsaw. Ogiński had just purchased a house outside of the city, in Helenów, and may have been offering the Rembrandt in exchange for orange trees for his new home. In any case, by 1791, Rembrandt's canvas appears in the royal collection's inventories.[23] In the catalogue of Stanisław August's paintings, compiled between 1784 and 1792, the painting is cited (in French) as "Rembrand, Cossack on Horseback."[24]

Stanisław August Poniatowski, the last sovereign of Poland, was elected (as per the custom in the Polish Commonwealth, where the monarchy was elective) in 1764, and he reigned for more than thirty years, until 1795.[25]

Born into a prominent Polish family, he had traveled around Europe in the 1750s, in pursuit of his passions for art and for the future Catherine the Great, with whom he had a long love affair. After his election, the king employed a number of foreign artists, among them, the Roman painter Marcello Bacciarelli (1731–1818), who became court painter in 1764 and executed most of the king's portraits (fig. 9), and the Venetian Bernardo Bellotto (1722–1780), who moved to Poland in 1767 and worked there for the last thirteen years of his life. Over the years, Stanisław August assembled a substantial collection of paintings, though their quality varied greatly as the king's financial means did not always support his tastes.[26] The king was said to have been particularly fond of horses and of paintings representing them. The dealers Noel Desenfans and Peter Francis Bourgeois, who were allegedly tasked with assembling a collection of paintings for the king in England, between 1790 and 1795, claimed that "as the King of Poland was fond of horses, his majesty particularly recommended the purchase of the works of those masters most celebrated for painting them."[27] *The Polish Rider* would have met with Stanisław August's approval, as Ogiński probably knew. The most important part of the king's collection of paintings was displayed in the Łazienki Palace (fig. 10), his favorite residence, which he had entirely redecorated; the rest was on view in the Royal Castle in Warsaw and in other locations.[28] *The Polish Rider* remained in the king's collection for only a few years. It appears in inventories between 1793 and 1795, valued between 180 and 200 ducats.[29] By 1795, the painting was in the antechamber (*antichambre en haut*) on the upper floor of the Łazienki Palace, at the entrance to a suite of rooms that led to the king's bedroom.[30]

Stanisław August's reign coincided with a volatile time in Poland's history. The Polish Commonwealth, as it was then known, comprised different parts of the states today known as Poland, Germany, Belarus, Ukraine, and Lithuania.[31] The borders of the commonwealth changed dramatically over the centuries; under Stanisław August, it was partitioned three times—in 1772, 1793, and 1795—among Russia (and the king's ex-lover), Prussia, and Austria. Eventually, the three countries annexed Stanisław August's kingdom, at which point, in November 1795, the king abdicated. Poland would cease to exist as a country on the world map until 1918, after World War I. Having given up his kingdom, Stanisław August planned to move to Rome but instead traveled to Grodno and then to Saint Petersburg, where he spent the

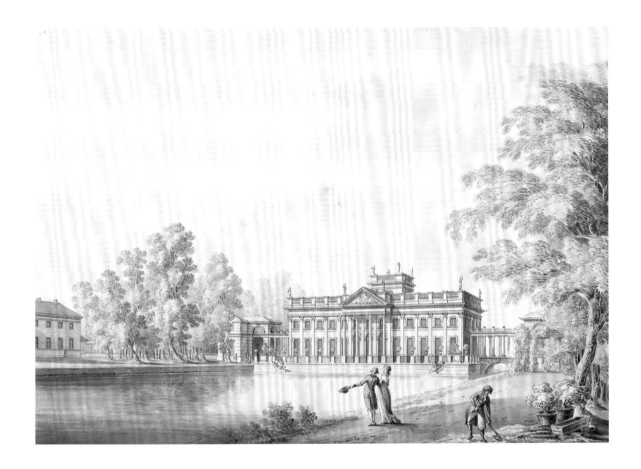

last two years of his life. Lists were made of the paintings meant to follow the king at Grodno, and *The Polish Rider* was among them.[32] On January 16, 1796, Marcello Bacciarelli informed the king that a number of paintings, including the Rembrandt, had been removed from the first-floor antechamber of the Łazienki Palace in preparation for their shipment.[33] The paintings were placed in thirteen crates, which were hidden first in the theater of the Royal Castle and subsequently in a boathouse at Łazienki.[34] They were, in fact, never sent to Russia but remained in Warsaw and, between 1797 and 1799, were unpacked and returned to the rooms of the Łazienki Palace: *The Polish Rider* is described as being in the picture gallery (*gallerie en bas*) on the ground floor.[35] On February 12, 1798, Stanisław August died of a stroke in the Marble Palace in Saint Petersburg.

Fig. 10
Zygmunt Vogel
Łazienki Palace, ca. 1790–1800
Watercolor on paper
13¼ × 19 in. (33.8 × 48.2 cm)
Muzeum Narodowe w
Warszawie, Warsaw

Fig. 11
Bertel Thorvaldsen
Józef Antoni Poniatowski,
1826–27
Plaster model
H. 182⅓ in. (463 cm)
Thorvaldsens Museum,
Copenhagen

Fig. 12
Jean-Pierre Norblin de la
Gourdaine, after Rembrandt
The Polish Rider, 1803
Pencil and brown, pink, and
ocher wash on paper
19 × 15¾ in. (48 × 40 cm)
Private collection

Sad Memories: Warsaw to Horochów, 1798–1815

After the king's death, his collection—still in Warsaw—was inherited by his nephew, Józef Antoni Poniatowski (1763–1813) (fig. 11) and remained in the Polish capital, likely on view at the Łazienki Palace. The first known copy of *The Polish Rider* dates to about this time, 1803, and was made by Jean-Pierre Norblin de la Gourdaine (1745–1830) (fig. 12).[36] On February 1, 1811, the young Polish aristocrat Waleria Stroynowska (1782–1849) saw Rembrandt's painting and recorded it in her diary. Visiting the Łazienki Palace that day with her mother-in-law, she noted, "This apartment of Stanisław August has remained absolutely in the same state since his departure from his capital to Grodno [in 1795]; this armchair, this desk, this inkwell, these pens, these scattered papers, this calendar open to the year 1794, all that hurts, and we

Fig. 13
Rembrandt van Rijn
The Scholar at the Lectern, 1641
Oil on poplar panel
41⅝ × 30⅛ in.
(105.7 × 76.4 cm)
The Royal Castle in Warsaw –
Museum

escaped with pleasure from these sad memories."[37] In the billiard room, the paintings gallery on the ground floor, she said that "among other several good Rembrandts" were "a Jew (fig. 13) and his daughter (fig. 14), and a Lisowczyk that Jaś persists in believing to be Stanislas Stroynowski—how I would love to buy that if I had the money, because in this beautiful and rich Łazienki everything is for sale."[38] Stroynowska's husband, Jan Feliks Tarnowski (1777–1842), believed *The Polish Rider* to be a portrait of his wife's distant ancestor Colonel Stanisław Stroynowski, who in the seventeenth century had been a member of the mercenary army under the command of Aleksander Józef Lisowski (ca. 1580–1616), active in Poland and Lithuania during the Thirty Years' War.[39] The soldiers following him were known in Poland as

Fig. 14
Rembrandt van Rijn
The Girl in a Picture Frame, 1641
Oil on poplar panel
41½ × 30 in. (105.5 × 76.3 cm)
The Royal Castle in Warsaw –
Museum

"Lisowczycy." Waleria Stroynowska's journal is the first evidence of the king's "Cossack" being renamed a "Lisowczyk."

If the king's collection was informally for sale by 1811, it remained in his possession until Józef Poniatowski—fighting on Napoleon's side against the Russians—died at the Battle of Leipzig, in October 1813. The collection at Łazienki was then inherited by Józef's sister, Maria Teresa Tyszkiewicz (1760–1834), who sold a number of the paintings in Warsaw between 1814 and 1821. The majority of the collection was eventually sold in 1817, together with the Łazienki Palace, to Tsar Alexander I. On June 3, 1814, *The Polish Rider* was sold to Franciszek Ksawery Lubecki (1778–1846) for 150 ducats, with Ernst Johann Sartorius de Schwanenfeld (1740–1820) acting as

intermediary.[40] Lubecki seems to have acquired the painting as an investment; a few months after his purchase, he resold it to Hieronim Stroynowski (1752–1815), Bishop of Vilnius, for the high price of 500 ducats. Stroynowski died in 1815. His younger brother, Walerian Stroynowski (1755–1834), inherited the painting and brought it to his house in Horochów (fig. 15) in Wołyń (in modern-day Ukraine).[41]

A Couple of Art Lovers: Dzików Castle, 1834–94

The Polish Rider probably remained at Horochów until Walerian Stroynowski's death, in 1834. Walerian may have given the painting to his daughter—that same Waleria Stroynowska (fig. 16) who had seen the painting at Łazienki in 1811 and had first described the figure as a Lisowczyk—at an unknown date before his death. In 1833, the painting was in Vienna, where it is documented as being restored for the first time.[42] It is unclear if it was sent there by Walerian or by his daughter. It is possible that Waleria and her husband Jan had, in fact, been behind Hieronim Stroynowski's acquisition of the painting, in 1814, as the couple were well known for their interest in the arts. Jan Tarnowski was a

Fig. 15
Ignacy Fudakowski
Walerian Stroynowski's house in Horochów
Photograph, 1915–16
Narodowe Archiwum Cyfrowe, Warsaw

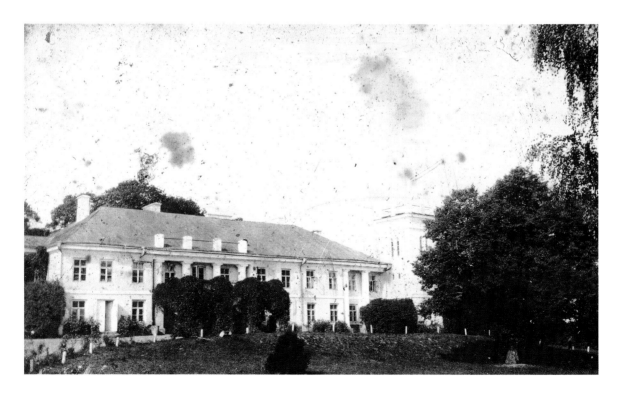

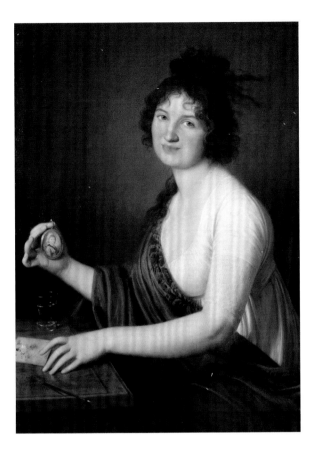

Fig. 16
Domenico del Frate
*Waleria Tarnowska née
Stroynowska*, 1805–6
Oil on canvas
38¼ × 28¾ in. (97 × 73 cm)
Muzeum Narodowe w Krakowie,
Kraków

bibliophile, and Waleria was particularly fascinated by the visual arts. Among the great works they acquired, the most important was Antonio Canova's *Perseus with the Head of Medusa* (now at the Metropolitan Museum of Art, New York), which they commissioned in Rome and had shipped to Poland in 1806. The couple established their residence in Dzików, the main seat of the Tarnowski family, in Galicia, in southeastern Poland, where the medieval manor house of the Tarnowski had been remodeled in the 1830s in the Gothic revival style (fig. 17).[43] *The Polish Rider* was moved to Dzików, where it remained, more or less uninterruptedly, for the next seventy-five years.

Four inventories record the painting as being in Dzików Castle between the 1830s and the early twentieth century. The first inventory, from about 1834, lists the Rembrandt in Waleria's drawing room: "Lisowczyk bought in Holland by Count Ogiński for the Picture Gallery of Stanisław August from where it got into the hands of Prince Józef Poniatowski, during the auction of

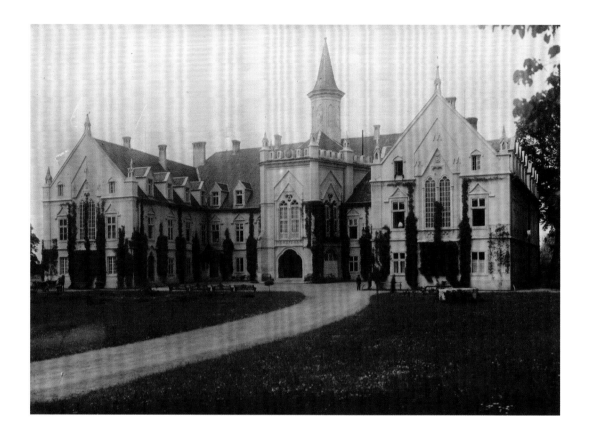

Fig. 17
Michał Affanasowicz
The Tarnowski castle in Dzików
Photograph, ca. 1917
Muzeum Historyczne Miasta
Tarnobrzega–Zamek w
Dzikowie, Tarnobrzeg; on
permanent loan from the
Tarnowski Collection

paintings from the Łazienki—it was bought from there by Bishop Stroynowski for #500."[44] By the time of the second inventory, on December 1, 1844, the painting still hung in the "Mistress's Drawing Room" (*Pokój bawialny Pani*).[45] The inventory also indicates that the painting had been purchased by "Ogiński in Amsterdam for king Stanisław August," but it is unclear how reliable this information is. In the early 1840s, the painting was published twice. The poet Kajetan Koźmian (1771–1856) saw the painting and described it in 1842 as a Lisowczyk in his biography of Jan Feliks Tarnowski.[46] The following year, Maurycy Dzieduszycki commented on how the canvas had "delighted the experts who without any doubts recognized in it Rembrandt's brushwork," while the painting had been sent for restoration in Vienna, in 1833.[47] After the deaths of Jan and Waleria Tarnowski, *The Polish Rider* was inherited by their eldest son, Jan Bogdan Tarnowski (1805–1850), and then by their grandson Jan Dzierżysław Tarnowski (1835–1894), and remained at Dzików. An 1872 inventory lists the painting as being in the great hall of the house.[48]

While Rembrandt's painting remained at Dzików Castle through most of the second half of the nineteenth century, it seems to have been largely forgotten by foreign scholars. Wilhelm von Bode (1845–1929), the director of the Berlin museums, claimed to have seen *The Polish Rider* in Vienna "some time ago," when the painting was being restored, and published it in 1883.[49] The canvas had, in fact, been in Vienna in 1877, possibly for sale.[50] By the early twentieth century, the painting belonged to the fourth generation of the Tarnowski family, to Jan and Waleria's great-grandson, Zdzisław (1862–1937). An inventory compiled before 1910 laconically described the "Rembrandt Lisowczyk" in the drawing room of "the elder countess," Zdzisław's mother, Zofia Tarnowska, née Zamoyska (1839–1930).[51]

The Galician Railways: Dzików Castle to Amsterdam, 1897–98

In the spring of 1897, Abraham Bredius (1855–1946), director of the Mauritshuis in The Hague, traveled to Poland and Russia to conduct research for a Rembrandt exhibition in Amsterdam. Bredius recalled that while waiting for a colleague at his hotel in Kraków in April, he was struck by a curious sight: "as I saw a magnificent carriage drawn by four horses pass my hotel, and learnt from the doorman that it was Count Tarnowski, who had been engaged to the beautiful Countess Potocka, who would bring him a considerable fortune upon marriage, little did I think how the man was also the lucky owner of one of the most wonderful works of our great Master."[52] The thirty-five-year-old Zdzisław Tarnowski was engaged to Zofia Potocka, whom he would marry on August 5, 1897. Upon inquiring, Bredius was told that Tarnowski owned a Rembrandt. Through the introduction of Jerzy Mycielski (1856–1928), a cousin of Tarnowski, Bredius was invited to visit Dzików, and the two traveled together to Galicia. Bredius later recalled: "it was a long way. And all those little spur lines of the Galician railways—everything goes so slowly that you could run next to the train if you were so inclined."[53] At the time, Mycielski was working on a catalogue of Stanisław August's collection and knew *The Polish Rider*.

They reached the castle during preparations for the impending wedding: "new stables were being built, the house was being worked in, everything for the impending marriage of course. There is a lot of rubbish on the walls of the gigantic hall in this curious building." In the house, Bredius was confronted for the first time with *The Polish Rider*: "there it hung! Only one gaze, a

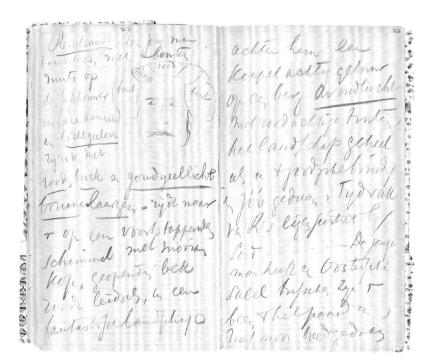

Fig. 18
Abraham Bredius's notebook,
April 1897
RKD – Netherlands Institute for
Art History, The Hague, Archive
Abraham Bredius

closer look of a few seconds as to technique were needed to convince me at once that there, hidden away in this isolated place, had been hanging one of Rembrandt's greatest masterpieces for almost 100 years!" As he stood in front of the painting, Bredius took some notes and sketched the painting (fig. 18).

Back in Holland, Bredius started working on his Rembrandt exhibition. Organized to celebrate the coronation of Queen Wilhelmina of the Netherlands, which would take place in the Nieuwe Kerk on September 6 of that year, the exhibition would be on view between September 8 and October 31, 1898, in the newly built Stedelijk Museum in Amsterdam.[54] Bredius would ultimately bring together one hundred twenty-three paintings by Rembrandt, the largest selection of works by the artist ever assembled at that time. Having rediscovered *The Polish Rider*, Bredius tried to convince Tarnowski to lend the painting to the exhibition. On June 27, 1898, he wrote to him about the "fine Cavalier by Rembrandt."[55] He stated that eighty-five works had already been promised to the exhibition, and they were to be lent by Queen Victoria, the English aristocracy, and all the great collectors of Europe—"but what a surprise, and what renewed admiration for the great Master when your magnificent picture, almost unknown, will reveal itself there in all its beauty."[56] Bredius continued:

I am almost certain that later on you would regret not having contributed to the success of this exhibition, which will be unique in the history of art! Just think, 85 works by one of the greatest artists in the world will be brought together! All expenses are paid by the Commission; risk is avoided in every possible way. The Museum is a fine new building which gives every guarantee against theft and fire. This exhibition will be the apotheosis of your picture; it will henceforward be ranked among the Masterpieces of our great Master.[57]

Except for two trips to Vienna, the painting had not left Dzików for more than sixty years, and Zdzisław Tarnowski was clearly nervous about lending it to the exhibition. Bredius wrote, "I understand that you are afraid of confiding it to strange hands, but Hauser's case will be a good one, and as soon as it is opened in Holland only pious hands will handle the picture . . . and as this jewel is kept in its case, well sheltered from sightseers in a corner of the world not easily accessible, you will bestow a great kindness in showing this jewel just for once to the public, and for two months only."[58] His powers of persuasion were well honed: "Make us happy, we will be grateful, and come and see with the Countess this interesting exhibition which will allow you to cast an eye over this curious little country which is called the Netherlands."[59] The painting ultimately traveled to Amsterdam, where it was on view as *Portrait of a Polish Rider, Wearing the Uniform of the Lysowsky Regiment, in a Landscape*.[60] The Lisowczyk had become *The Polish Rider*.

Reviewers of the exhibition were struck by Bredius's discovery in faraway Galicia. One of them commented that the painting, which was "very little known until recently," was "one of the most remarkable in the exhibition."[61] A reviewer in the *New York Times* called *The Polish Rider* one of the greatest "successes of the exhibition" and linked the painting to Russian literature: "it is like a leaf torn from the dark life pages of Taras Bulba or Nicholas Gogol."[62]

The Forest at Mokrzyszów: Dzików to New York, 1910
On April 15, 1910, the British art critic and curator Roger Fry (1866–1934) sent a cable to Henry Clay Frick, in New York: "Can secure rembrandts polish cavalier sixty thousand pounds urge acceptance decision must reach me eighteenth."[63] The next day, Fry explained that the painting was in excellent condition and had left Dzików Castle only once, for the 1898 Amsterdam exhibition.[64] Fry had not had time to see the painting in Poland but recommended its purchase. Frick immediately responded: "Purchase but

try for lower price, leave matter of condition of picture with you, payment should be made on delivery here but you have authority to do as you think best in all matters."[65]

In a subsequent letter, from April 24, Fry explained his involvement in the sale.[66] After the 1898 exhibition, *The Polish Rider* had become a famous and valuable painting. Zdzisław Tarnowski (fig. 19)—whom Fry described as "a good natured rather rustic country gentleman with the obstinate suspicions of a peasant type quite unused to business and extremely difficult to deal with, especially as he only spoke bad French"—had decided to sell the painting in 1910 and had put his younger brother Adam (1866–1946), a diplomat at the Austrian Embassy in London, in charge of the sale. Zdzisław had wanted to sell the painting for half a million francs but had received an offer for 44,000 pounds with an expiration date of April 20. Looking into the value of the painting, Adam Tarnowski, in London, contacted Carfax & Co., one of the local galleries. In April 1909, Fry had had an exhibition of his own work at the gallery, and the principal there, Arthur Clifton, immediately contacted Fry after Tarnowski's enquiry. Fry thought that the price offered was low and that Tarnowski could sell it for more. When asked about a possible buyer, Fry thought of Frick, who was known for his purchases of Old Master paintings. Fry thought a reasonable price would be between 80,000 and 100,000 pounds. He and Tarnowski ultimately agreed on 60,000 pounds, whereupon Fry offered the painting to Frick.

The whole affair transpired over just a few days. Only four days after the initial cable, on April 19, Fry wrote: "Sale concluded but Count insists I inspect picture in situ and deposit total price at once in Wiener Bank Verein Vienna to be handed to him on my approval."[67] Zdzisław Tarnowski insisted that Fry travel to Poland to pick up the painting. A day later, Fry wrote to New York again: "Owner honest country gentleman, unbusinesslike, very nervous. Insists on selling picture from Chateau. I receive it there against check. . . . I going Tarnowsky Chateau great personal inconvenience."[68] Frick responded that same day: "Have cabled sixty thousand pounds to your credit . . . would like picture to remain in Paris that my family may see it. They sailed yesterday."[69] On April 25, Fry traveled to Poland. The previous day, he had written to his mother:

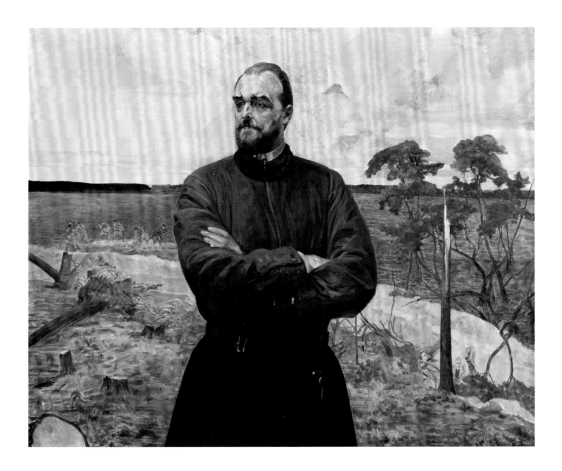

Just now I have to go to Poland to buy for Mr. Frick a very important picture. . . . The owner is a rather stupid country gentleman who insists on selling the picture in his château; that's why I have to go and get it, and I must see it before buying. . . . It's tiresome and rather hateful work but I couldn't refuse to do it. I hope Mr. Frick will be more decent to me than his fellow millionaire. At all events I ought to get handsomely paid for all I have done and indeed it comes at a critical time, for I am just at the end of my resources and have been feeling very anxious of late as to how I can possibly meet expenses.[70]

Fig. 19
Jacek Malczewski
Zdzisław Tarnowski, 1920
Oil on canvas
46½ × 59 in. (118 × 150 cm)
Muzeum Historyczne Miasta Tarnobrzega–Zamek w Dzikowie, Tarnobrzeg; on permanent loan from the Tarnowski Collection

By June 6, Frick had paid a 5 percent commission of 3,000 pounds to Fry. In the spring of 1910, *The Polish Rider* left Poland. The Polish press hardly commented on the sale, and only one writer criticized it.[71] In May 1910, as the sale was concluded, Fry wrote from Vienna to his wife: "They [Poles] are a queer, medieval people, but seem to manage their affairs very happily."[72]

On May 3, Fry wrote to Frick: "Picture dispatched Paris good condition."[73] Frick, who usually acquired his works from Knoedler & Co., confessed to

Roland Knoedler on May 13: "Would have preferred to have purchased this Rembrandt through you, but I did not want to lose the opportunity of securing it; while I paid a very high price, yet the picture is unique, being as I am told, one of the two equestrian portraits by the artist."[74]

Two issues needed to be resolved before the painting could be sent to New York. Zdzisław Tarnowski had asked Fry for an exact copy of the painting to display at Dzików. The painting was sent to London, where the painter Ambrose McEvoy (1878–1927) produced a copy in early July 1910. On January 22, 1911, Tarnowski wrote from Dzików that he had received the painting and that "the copy of the 'Lisowczyk' is truly remarkably beautiful."[75] Fry had written to Frick on May 9, 1910, about a second issue: "One other matter I must see about and that is the frame. The present one is altogether impossible and I am trying to find a suitable old one."[76] This was resolved a few months later: "Knoedler has found a frame which suits the picture admirably and it looks incredibly beautiful," Fry wrote on June 17.[77] Frick paid $850 for the new frame on October 14. The histories of the copy and the frame are inextricably linked. While the original Rembrandt traveled to America in its new frame (which is the present-day frame on the painting at The Frick Collection), the copy by McEvoy was sent to Dzików. A photograph from 1917 shows the copy on the landing of the main staircase (fig. 20). The frame in which the copy was displayed is most likely the frame that surrounded the Rembrandt before it was sold. Once Fry had determined that the frame was "altogether impossible," he probably discarded it and left it at Dzików. Tarnowski's desire to have a copy was probably dictated in part by the fact that he still had the frame. It may also be that *The Polish Rider* had traveled to London in its old frame and that, once discarded, it was placed on the copy. The photograph further demonstrates that at Dzików the Rembrandt was most likely mounted in the frame that was made for the picture while it was in the collection of Stanisław August at the Łazienki Palace; some of the existing paintings from the king's collection have similar frames.[78] In December 1927, a fire devastated Dzików Castle; both McEvoy's copy and the frame were destroyed.

Soon after Frick's purchase of the painting, stories started circulating in the press. On April 26, 1910, the *New York Times* reported the following: "Count Zadislas Tarnowski of Cracow, it is rumored in London art circles, has sold his fine Rembrandt entitled 'The Polish Rider' for $300,000. It was

rumored that it had been purchased for the Metropolitan Museum of Art, but it was stated at the Museum yesterday that this is erroneous." By July 3, the newspaper announced that "the magnificent Rembrandt 'The Polish Rider' which Henry C. Frick has purchased through Carfax & Co. of London, will probably soon be in New York, and Londoners have been having a last opportunity to look at it at the Carfax Galleries." For most of June of that year, Carfax had shown the painting in its gallery, before sending it to New York. The painting reached Frick on July 21 at Eagle Rock, his summer home at Pride's Crossing, Massachusetts. The next day, he cabled Fry with one word: "Enchanted."[79]

Frick paid $308,651.25 for *The Polish Rider*: $293,162.50 for the painting, $14,613.75 for the commission to Fry, $850 for the frame, and $25 in duty charges.[80] Frick was a known admirer of Rembrandt's work and had purchased a number of works by him. However, just as Jan Feliks Tarnowski had believed in 1811 that *The Polish Rider* represented his wife's ancestor, a later descendant of the Frick family suggested a romantic and undocumented motive behind his acquisition of it. According to Frick family biographer Martha Frick Symington Sanger (who did not realize that Frick bought the painting without ever having seen an image of it), the figure in the painting

Fig. 20
Michał Affanasowicz
Copy of *The Polish Rider* at the Tarnowski castle in Dzików
Photograph, 1917
Muzeum Historyczne Miasta Tarnobrzega–Zamek w Dzikowie, Tarnobrzeg; on permanent loan from the Tarnowski Collection

reminded Frick of a late-night business ride he once took as a young man on his gray horse Billy.[81] The same author believed that Frick further identified with the youth on horseback because he was a mason. Sanger also suggested that Frick identified with the landscape, which reminded him of the mining landscape around Pittsburgh, and the rider's war hammer, which evoked a miner's pick. And finally, Sanger claimed Frick may have been drawn to the painting because of the similarity of the rider's features with those of his daughter, Helen.[82] The likeness between the young rider and Helen Clay Frick, as shown in a passport photograph from 1917, is, in fact, striking (figs. 21 and 22), but there is no evidence that it figured into Frick's purchase.[83]

Zdzisław Tarnowski and his wife, Zofia Potocka, were among the wealthiest people in Poland in the early twentieth century. So why did they sell *The Polish Rider*? After the partition of Poland in 1795, the area of Kraków and Galicia, where the Tarnowski lived, was under Austrian rule.[84] During the century when Poland did not exist as a country, the Poles attempted, on a number of occasions, to reclaim their homeland. At the end of the nineteenth century, images of Polish riders, Cossacks, and Lisowczyk became potent symbols of a growing nationalism. Painters such as Juliusz Kossak (1824–1899) and Józef Brandt (1841–1915) knew *The Polish Rider* and used it as a model for some of their works, to illustrate ideal images of the Polish people (fig. 23). The Austrians did not recognize many of the land properties of the Polish aristocracy, such as the large tracts of land in the Sandomierz forest to which the Tarnowski had had rights since the Middle Ages. Jan Bogdan Tarnowski had attempted to buy back some of this land but did not have

Fig. 21
Helen Clay Frick's passport photo, 1917
The Frick Collection/Frick Art Reference Library Archives, New York

Fig. 22
Rembrandt van Rijn
Detail of *The Polish Rider*, ca. 1655
Oil on canvas
46 × 53⅛ in. (116.8 × 134.9 cm)
The Frick Collection, New York

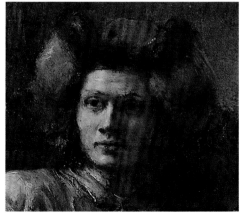

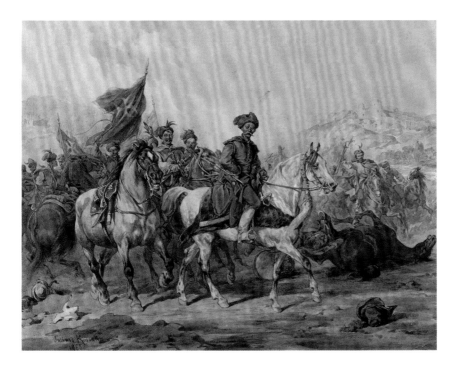

Fig. 23
Juliusz Kossak
Lisowczycy, 1880
Watercolor on paper
28⅜ × 32⅞ in. (720 × 835 mm)
Muzeum Narodowe w Kielcach,
Kielce

sufficient resources.[85] In the early twentieth century, the land had belonged to a German named David Franke. When he decided to sell one of his estates, at Mokrzyszów, Zdzisław Tarnowski, together with his brothers Juliusz and Adam and their uncle Stanisław, purchased it. The money used to buy the land came from Zdzisław's wife's dowry and from the sale of *The Polish Rider*. At a time when aristocratic families were trying to secure as much of their homeland as possible to keep it in Polish hands, the Tarnowski sale of a work of art for this purpose was seen as a patriotic act. In May 1910, after returning from Poland, Roger Fry wrote to his wife:

> On the way from Dzików I saw two storks in their nests. It's a wonderful sight. The bird and the nest both look so much too big for the trees. Like this, only you must imagine that this is quite a big tree and you'll see how top heavy the whole thing looks, but the storks seemed quite happy up there. The Poles seem to dream of having their country back again and indeed it seems quite monstrous that they shouldn't. For they are quite a big people with a great deal of national feeling. . . . I can't understand why one country ever should govern another, can you? Only we are rather bad offenders in that way.[86]

Savage Magnificence: Amsterdam, ca. 1655

By the time The Frick Collection opened to the public in 1935, Rembrandt's painting had been known by three different titles. Between 1791 and 1814, it was known as the *Cossack on Horseback*. When Jan Feliks and Waleria Tarnowski identified the youth as a Lisowczyk, in 1811, that name became attached to the painting in Poland, where it is still known as such. By the time the canvas was exhibited in Amsterdam in 1898, it had become *The Polish Rider*, as it has been known in English ever since. But what is the meaning of this painting?

In Poland, Rembrandt's painting and the military figure of a Lisowczyk became conflated. Even though Lisowczycy did not have specific uniforms— and no contemporaneous evidence survives as to what they wore—the figure in *The Polish Rider* was crucial in shaping the appearance of Lisowczycy in the Polish imagination. In 1843, an article and a book about Lisowczycy, by Maurycy Dzieduszycki, were accompanied by a print after Rembrandt's painting to show what a Lisowczyk wore (fig. 24).[87] In his text, Dzieduszycki also claimed that the Tarnowski coat of arms (known in Polish as Leliwa)—a

Fig. 24
Unknown artist after Rembrandt
"Lisowczyk"
From Dzieduszycki 1843b

LISOWCZYK.

Fig. 25
Unknown artist after a drawing
by Juliusz Kossak
"Lisowczyk"
From *Tygodnik Ilustrowany*,
vol. 10, 1859, p. 77
Woodcut on paper
6¼ × 5⅜ in. (160 × 138 mm)
Biblioteka Narodowa, Warsaw

star, superimposed on a crescent moon—could be seen on the quiver of the rider. Even though there is clearly no Leliwa in the painting, a Polish periodical published, in 1859, an illustration of a Lisowczyk that was clearly based on Rembrandt's painting, and it included a prominent Leliwa on the figure's quiver (fig. 25).[88]

It has been argued that the costume worn by *The Polish Rider* may not even be Polish.[89] But the studies of art historian Zdzisław Żygulski demonstrate that most of what the rider is wearing is indeed Polish.[90] The clothes and weapons are consistent with what would have been worn and used by the Polish light cavalry. The rider wears a long quilted coat with buttons running along its front. This is known in Polish as a *żupan*, and a number of

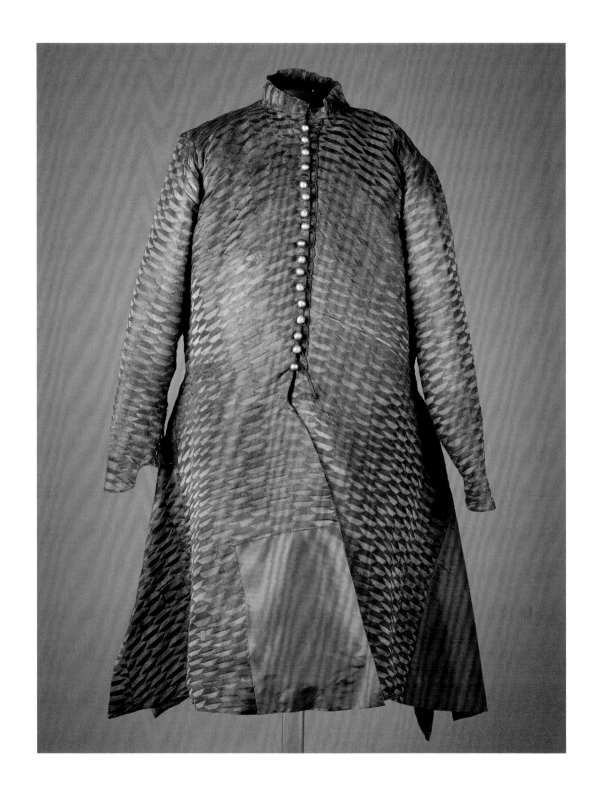

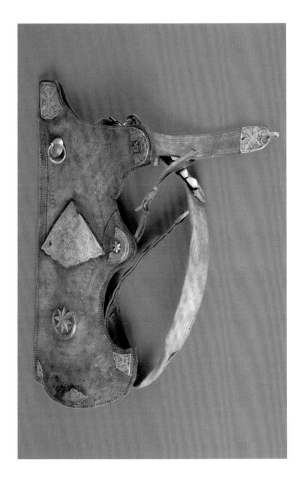

Fig. 26
Żupan, first half of 17th century
Italian silk damask, metal
buttons
H. 40½ in. (103 cm)
Muzeum Narodowe w
Warszawie, Warsaw

Fig. 27
Quiver, 17th century
Leather and brass
17⅛ × 9⅝ in. (43.5 × 24.4 cm)
Muzeum Narodowe w Krakowie,
Kraków

Fig. 28
Karabela (saber) with half-closed
hilt, 1625–50
Steel and silver plate
H. 36⅝ in. (93 cm)
Muzeum Narodowe w Krakowie,
Kraków

Fig. 29
Nadziak (war hammer),
17th century
Steel, wood, and silver plate
27½ × 6½ in. (69.9 × 16.6 cm)
Muzeum Narodowe w Krakowie,
Kraków

Fig. 30
Bunchuk, 17th century
Silver, gold, nephrite, turquoise,
golden thread, and horsehair
H. 39⅜ in. (100 cm)
Muzeum Narodowe w Krakowie,
Kraków

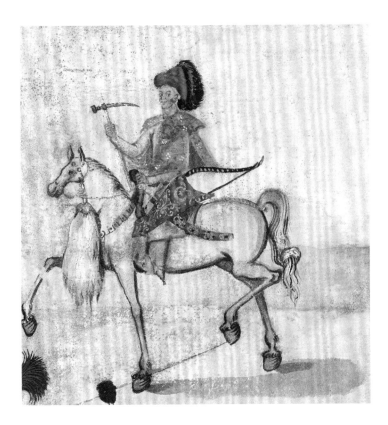

Fig. 31
Unknown artist
Stockholm Scroll (detail),
after 1605
Paper, watercolor, gouache,
tempera, ink, and golden paint
on paper
10⅝–11 × 601⅝ in.
(27–28 × 1,528 cm)
The Royal Castle in Warsaw –
Museum

seventeenth-century examples survive (fig. 26).[91] The fur hat, a *kutchma*, is of a type that originated in Mongolia and became popular in Persia, among the Tatars, in Russia, and in Lithuania.[92] The bow, quiver, and arrows also followed an Asiatic type, which was common in Poland and was created by Armenian craftsmen in Lviv (fig. 27).[93] Polish cavalry often wore two sabers (*karabela*, named after a location near Baghdad), and their depiction in the painting is consistent with seventeenth-century examples (fig. 28). The war hammer, or *nadziak,* was of Scythian origin and was also used by Polish cavalry (fig. 29).[94] The breed of horse, the saddle over a leopard skin, and even the horse's tail—cut and attached as a decoration to the neck of the animal, a *bunchuk* (fig. 30)—are typically Polish.[95] A figure wearing most of the rider's accoutrements appears in the *Stockholm Scroll*, a depiction by an anonymous painter of the 1605 wedding procession of King Zygmunt III and Constance of Austria into Kraków (fig. 31).[96]

Polish costumes were based on a rich mixture of western and eastern fashion (fig. 32).[97] This was partly a reflection of the myth that Polish people descended from the Sarmatians, a nomadic people from Persia.[98] As the historian Adam Zamoyski has explained:

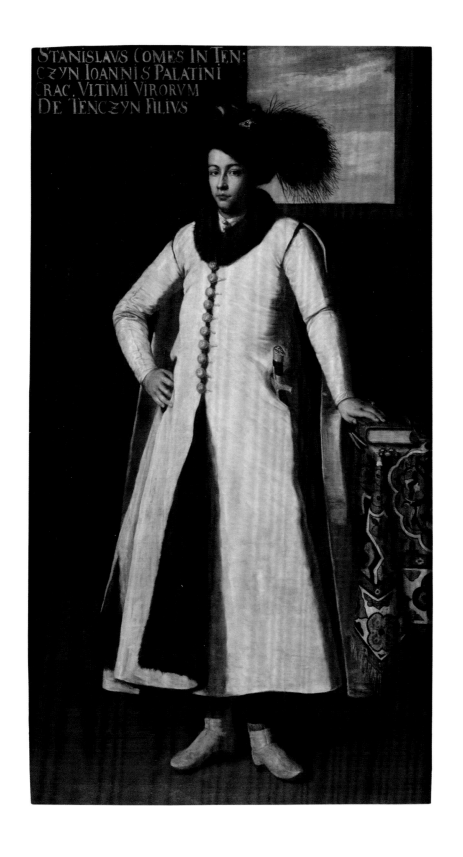

STANISLAVS COMES IN TEN:
CZYN IOANNIS PALATINI
CRAC. VLTIMI VIRORVM
DE TENCZYN FILIVS

as a result of contacts with Hungary and Ottoman Turkey various accoutrements of Persian origin were gradually incorporated into everyday use, and by the end of the [sixteenth] century a distinctly oriental Polish costume had evolved. . . . The Poles were close to their horses, which were symbols of their warrior status. They were tacked in fine harness, covered in rich cloths, adorned with plumes and even wings, and, on high days and holidays, dyed (usually cochineal, but black, mauve or green were favoured for funerals). . . . The Polish Commonwealth was turning into a hybrid of East and West, increasingly exotic but also baffling to western Europeans. . . . This Sarmatian lifestyle was a unique growth, produced by cross-pollination between Catholic high Baroque and Ottoman culture.[99]

Western Europeans were fascinated by Polish costume, especially when large embassies from Poland visited. Two such celebrated events were the establishment of the Polish embassy of Jerzy Ossoliński in Rome in 1633 and that of Krzysztof Opaliński in Paris in October 1645.[100] Upon witnessing the latter, Françoise de Motteville, one of the ladies-in-waiting of the French queen, Anne of Austria, commented: "there is something in their magnificence, which looks very savage."[101] The Florentine printmaker Stefano della Bella (1610–1664) portrayed members of the Polish embassies in Paris and Rome and produced other images of Polish cavalry (fig. 33).[102]

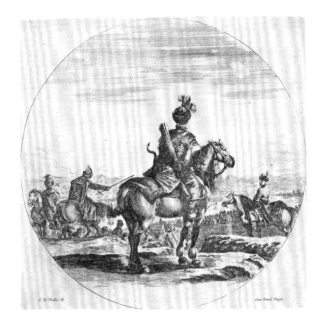

Fig. 32
Attributed to Tommaso Dolabella
Stanisław Tęczyński, ca. 1630
Oil on canvas
76¾ × 42½ in. (195 × 108 cm)
Muzeum Narodowe w Warszawie, Warsaw

Fig. 33
Stefano della Bella
Polish Horseman, ca. 1651
Etching on paper
7¼ × 7¼ in. (185 × 185 mm)
The Metropolitan Museum of Art, New York

The Polish Rider has often been interpreted as Rembrandt's portrait of a foreign cavalryman. The tradition of representing Polish riders dates to fifteenth- and sixteenth-century prints by northern artists like the Master of the Housebook and Hans Sebald Beham (1500–1550). Della Bella's etchings of Poles, Hungarians, and Turks were also popular in the seventeenth century, and it is likely that he knew Rembrandt.[103] The Dutch painter was fascinated by foreign costumes and exotic images;[104] it has been noted that he demonstrated a "very arbitrary use of foreign costumes which he collected for their exotic appearance and material beauty and which reappear constantly in his paintings in new combinations."[105] The inventory of Rembrandt's house on the Breestraat—drawn up, with his help after his bankruptcy, in July 1656, by the secretary of the Insolvency Court—describes a number of curiosities, weapons, and oriental objects.[106] Rembrandt was also captivated by Amsterdam's Jewish community and produced a number of portraits of Jewish sitters and subjects.[107] In the mid-1650s, he is known to have copied a series of Indian Mughal miniatures (fig. 34), intrigued by their exotic costumes and weaponry.[108] These drawings have been linked to the exotic look of *The Polish Rider*.[109]

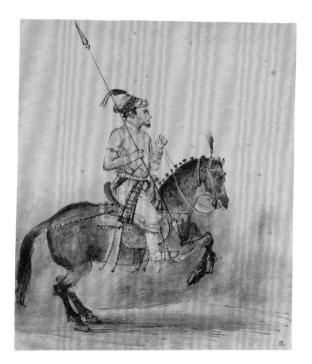

Fig. 34
Rembrandt van Rijn
A Mughal Nobleman on Horseback, ca. 1656–61
Brown ink and brown and gray wash with red chalk wash and red and yellow chalk lightly toned with light brown wash on Asian paper
8⅛ × 7 in. (205 × 177 mm)
The British Museum, London

But does Rembrandt's painting represent a Polish cavalryman he saw in Amsterdam? Does it represent a Pole, or a Dutchman dressed as a Pole? One of the most cosmopolitan cities of Europe, Amsterdam had a sizable Polish population in the seventeenth century.[110] Links between Holland and Poland were particularly strong, so a Polish patron could very well have commissioned the work. Furthermore, Rembrandt was closely connected to a number of Poles in Amsterdam. Hendrick van Uylenburgh, with whom Rembrandt lived when he first moved to Amsterdam and whose house was next to the one in which Rembrandt painted *The Polish Rider*, had ties to Poland through his father and brother, who had worked in Kraków and Gdańsk as cabinetmakers and painters.[111] Also, Saskia, Rembrandt's wife, had a sister, Antje, who was married to a Polish theologian, Jan Makowski (1588–1644).

It has often been argued that *The Polish Rider* is a portrait of a specific person. Walter Sickert believed the subject to be Rembrandt's son Titus, but this is unlikely since Titus was fourteen at the time the canvas was painted.[112] More recently, it has been argued that the painting portrays Marcjan Aleksander Ogiński (1632–1690), an ancestor of the first owner of the painting. Ogiński and his cousins, the brothers Jan and Szymon Karol Ogiński, studied at the universities of Franeker and Leiden and are known to have lived in the Netherlands.[113] Unfortunately, no portraits of them survive, and it is still unclear how Michał Kazimierz Ogiński came into possession of *The Polish Rider*, in 1791. A more unusual theory sees in the portrait an ideal image of Jonasz Szlichtyng (1592–1661), who published *Apologia* in Amsterdam in 1654.[114] Szlichtyng was a member of the Socinians, or Polish Brethren, a type of Anabaptist group, close to the Mennonites. Known at the time under the pseudonym Eques Polonus (the Polish Knight), Szlichtyng advocated for freedom and tolerance. Nevertheless, it is doubtful that Rembrandt would have represented a well-known pacifist as armed for combat.

A remarkable portrait by Rembrandt's pupil, Ferdinand Bol (1616–1680), painted in 1656—at the same time that Rembrandt was painting *The Polish Rider*—depicts a Dutch boy, Otto van der Waeyen (fig. 35). The child is shown in an outfit almost identical to that in Rembrandt's painting.[115] He wears a *żupan* and has a bow and arrows and a *nadziak* (war hammer) in his right hand. Why this eight-year-old Dutch boy, with no known links to Poland, was shown in this way remains a mystery.

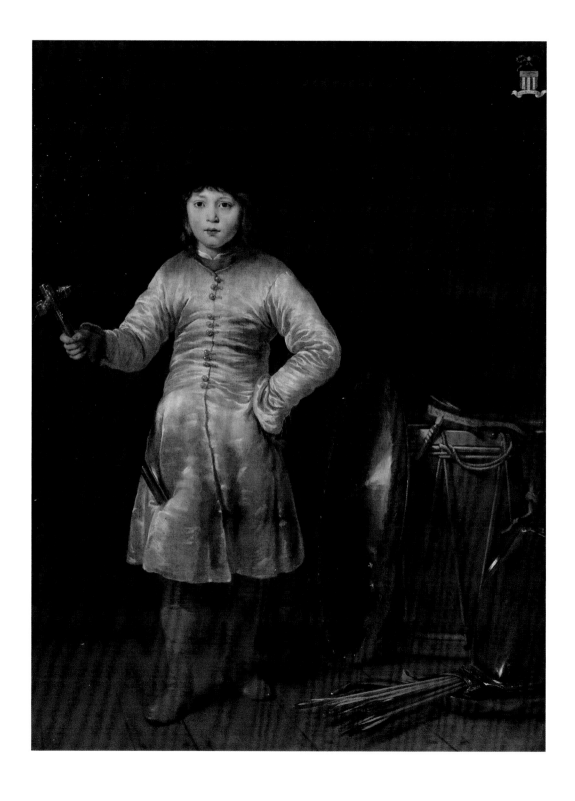

If *The Polish Rider* is a portrait, it is unusual in terms of its format. Not many equestrian portraits were produced in the Netherlands in the seventeenth century. Among these are Paulus Potter's (1625–1654) portrait of Diderik Tulp of 1653 (fig. 36) and Rembrandt's own portrait of the banker Frederick Rihel, of about 1663 (fig. 37).[116] Both are life-size, following the tradition of Titian, Rubens, Velázquez, and Van Dyck. *The Polish Rider* is altogether different in format, size, and mood. A drawing by Rembrandt that depicts the skeletons of a rider and his horse (fig. 38) has been linked to *The Polish Rider* and may indeed have been useful when the artist conceived his painting.[117] The skeletons must have been drawn in an anatomy theater, and the study of the horse may explain the emaciated appearance of *The Polish Rider*'s mount.

Efforts to associate Rembrandt's rider with a historical figure or character in literature have proved equally unpersuasive. Among those proposed are Gysbrecht van Aemstel, the medieval Dutch hero who founded Amsterdam, and Tamerlane pursuing Bayazet outside Constantinople.[118] Both of them were celebrated in plays in Rembrandt's lifetime. Van Aemstel appeared as the protagonist in a play by Joost van den Vondel (1587–1679), while Tamerlane was at the center of a play by Jan Serwouters (1623–1677) of 1657, in which the actors, surprisingly, were described as wearing Polish costumes. Another play possibly connected to *The Polish Rider* is *Sigismundus van Poolen*, written by an anonymous author, first performed in 1647 and published in 1654, which recounts the adventures of a maiden dressed up as a male soldier who pretends to be a Polish nobleman.[119] Kenneth Clark had also proposed, startlingly, that the model used by Rembrandt for *The Polish Rider* may have been female.[120]

The rider in the canvas has also been interpreted as the Wandering Jew and a number of other biblical characters: young King David, Esau riding after he sold his birthright, the Prodigal Son setting out from his father's house, or even Nimrod, the builder of the Tower of Babel.[121] The most poetic reading remains that of Julius Held, who saw the rider as the embodiment of a *miles christianus* (Christian soldier) fighting against the Turks in the seventeenth century: the "apotheosis of those soldiers of Eastern Europe who were still carrying on the traditions and ideals of Christian knighthood . . . the shining youth who himself seems to be in search of something distant, unmindful of things close and familiar, still withholds from us, like another Lohengrin, the secret of his name."[122]

Fig. 35
Ferdinand Bol
Otto van der Waeyen in a Polish Costume, 1656
Oil on canvas
62¼ × 47½ in. (158 × 120.5 cm)
Museum Boijmans Van Beuningen, Rotterdam

Following pages:
Fig. 36
Paulus Potter
Equestrian Portrait of Diderik Tulp, 1653
Oil on canvas
131½ × 107¼ in.
(334 × 272.5 cm)
Six Collection, Amsterdam

Fig. 37
Rembrandt van Rijn
Frederick Rihel on Horseback, ca. 1663
Oil on canvas
116 × 94⅞ in. (294.5 × 241 cm)
The National Gallery, London

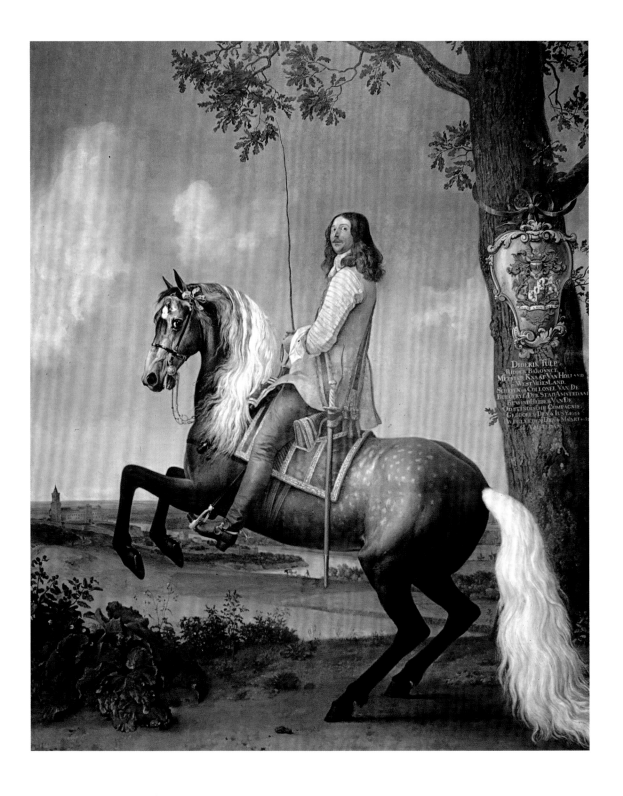

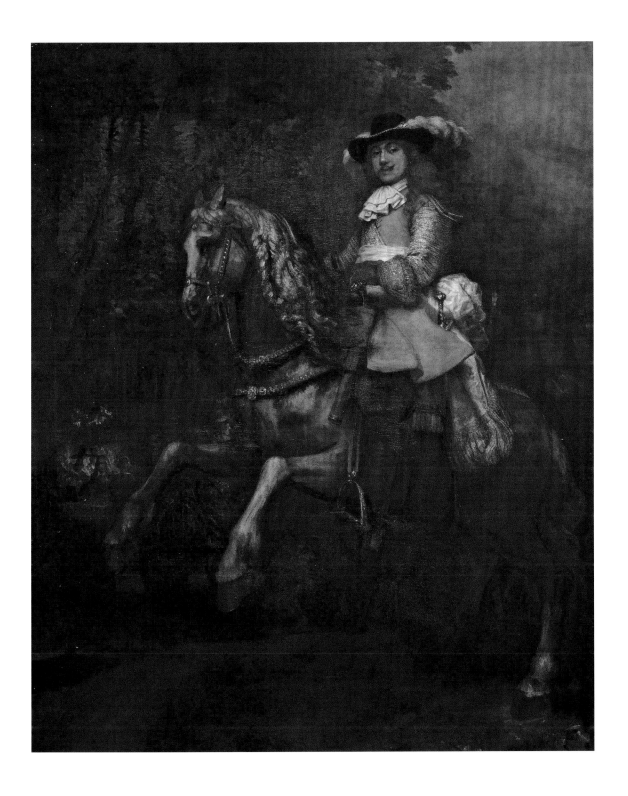

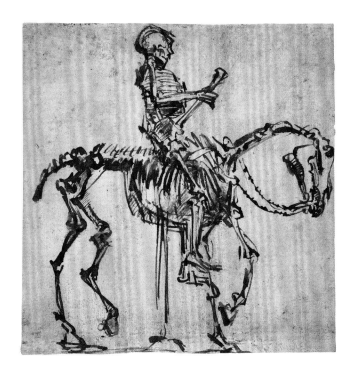

Fig. 38
Rembrandt van Rijn
Skeleton Rider, 1655
Brown ink on paper
6 3/16 × 6 1/16 in. (157 × 154 mm)
Hessisches Landesmuseum,
Darmstadt

* * *

We do not know for whom Rembrandt painted *The Polish Rider* or what he intended it to symbolize. How it came to be in Michał Kazimierz Ogiński's possession, in 1791, is also shrouded in mystery. Notwithstanding his rigorous and exhaustive study of the painting, Julius Held had to admit: "the Rider still withholds much from our ever-questioning minds."[123] Two former curators at The Frick Collection reached similar conclusions: *The Polish Rider* "still eludes a precise iconographical interpretation—an unknown youth riding at twilight through an ominous landscape, with towers, cliffs, and a dimly discernible pond at the edge of which glows a fire, while waiting" and "try as they may, historians have been unable to find any narrative—biblical, historical, or literary—that satisfactorily explains the subject of Rembrandt's painting."[124] But the fascination with the painting endures. *The Polish Rider* has signified different things to different people over more than two hundred years. And yet no satisfactory explanation for the painting has been reached. "Beyond that"—as Kenneth Clark hauntingly wrote—*The Polish Rider* remains "something mysterious, some memory of a journey into the world of the imagination where we cannot accompany him."[125]

HAVING A COKE WITH YOU

is even more fun than going to San Sebastian, Irún, Hendaye, Biarritz, Bayonne
or being sick to my stomach on the Travesera de Gracia in Barcelona
partly because in your orange shirt you look like a better happier St. Sebastian
partly because of my love for you, partly because of your love for yoghurt
partly because of the fluorescent orange tulips around the birches
partly because of the secrecy our smiles take on before people and statuary
it is hard to believe when I'm with you that there can be anything as still
as solemn as unpleasantly definitive as statuary when right in front of it
in the warm New York 4 o'clock light we are drifting back and forth
between each other like a tree breathing through its spectacles

and the portrait show seems to have no faces in it at all, just paint
you suddenly wonder why in the world anyone ever did them
 I look
at you and I would rather look at you than all the portraits in the world
except possibly for the *Polish Rider* occasionally and anyway it's in the Frick
which thank heavens you haven't gone to yet so we can go together the first time
and the fact that you move so beautifully more or less takes care of Futurism
just as at home I never think of the Nude Descending a Staircase or
at a rehearsal a single drawing of Leonardo or Michelangelo that used to wow me
and what good does all the research of the Impressionists do them
when they never got the right person to stand near the tree when the sun sank
or for that matter Marino Marini when he didn't pick the rider as carefully
as the horse
 it seems they were all cheated of some marvelous experience
which is not going to go wasted on me which is why I am telling you about it

—*Frank O'Hara*

Notes

1 Yourcenar 1957, 127–28.

2 "Under Iris Murdoch's Exact, Steady Gaze," by John Russell (*New York Times*, February 22, 1990), records the British writer's love for Rembrandt's painting.

3 Martineau 2016, 6–7.

4 Sickert 1947, 161.

5 Wurzbach 1906, 573. In the 1910 and subsequent editions of his book, Wurzbach gave the painting back to Rembrandt.

6 Apart from Bruyn and van de Wetering, the other members of the RRP were Jan Ameling Emmens, Jan G. van Gelder, Simon H. Levie, Bob Haak, and Pieter J. J. van Thiel.

7 Bruyn 1984, 158.

8 For the best summaries of the controversy, see Bailey 1990 and Bailey 1994. An amusing article—"Artist's Notebook: Back in the Saddle" by Russell Connor—appeared in the *New Yorker* on February 22, 1993. The article jokingly claimed that a self-portrait by Rembrandt, showing him painting *The Polish Rider* (in fact painted by the author of the article), had been discovered in a basement in Pinsk.

9 Bikker 2005, 32, 147–49, no. R16.

10 Van de Wetering 2009, 209–10; van de Wetering 2011, 535–50, no. V 20; van de Wetering 2014, 627, no. 236.

11 Van de Wetering 2011, 535–50, no. V 20; van de Wetering 2014, 627, no. 236.

12 For the alterations to the size of the painting, see Davidson 1968, 260; Bredius 1969, 571; Colin B. Bailey in New York 2011, 39–40; van de Wetering 2011, 535–50, no. V 20. The inventory describing the painting in the Łazienki Palace in 1795 (for which, see later) gives the dimensions of the painting as 42⅞ by 52¾ in. (109 × 133.9 cm)—they are now 46 by 53⅛ in. (116.8 × 134.9 cm)—demonstrating that at that time the canvas was somewhat shorter but just slightly wider.

13 Bode 1883, 499; Davidson 1968, 258; Prymak 2011, 162.

14 Clark 1978, 59–60.

15 For Rembrandt's well-documented biography, see, most recently, Schama 1999; Ford 2007; Silver 2018.

16 Nadler 2003, 9.

17 Ford 2007, 44.

18 Ibid., 58.

19 For *The Night Watch*, see, most recently, Bikker 2013.

20 *The Polish Rider* was first dated about 1655 in Amsterdam 1898, no. 94. The date has not since been questioned.

21 For the most complete studies on the painting's provenance, see Held 1944; Ciechanowiecki 1960; Van de Wetering 2011, 535–50, no. V 20.

22 Ciechanowiecki 1960, 295. For the interpretation of the letter and Ogiński, see Ciechanowiecki 1960.

23 For the king's collection, see Mańkowski 1929; Juszczak and Małachowicz 2016.

24 *Inventory 1784–92*, no. 1734: "Rembrand, Cosaque à cheval." I would like to thank Dorota Juszczak, the foremost expert on the collection of Stanisław August, for sharing with me important unpublished information about the king's collection and inventories, which will appear in her forthcoming book on the subject.

25 For the most complete biography of Stanisław August, see Zamoyski 1992.

26 "Stanisław August's financial means did not match his artistic ambition and he could rarely afford art of the highest calibre." Dorota Juszczak and Hanna Małachowicz in London 2009, 17. For the king's collection, see Zamoyski 1992; London 2009.

27 Ian A. C. Dejardin in London 2009, 8.

28 Approximately 320 paintings, out of a collection of about 2,500 works, were on display at the Łazienki Palace in 1795.

29 *Inventory 1793*, no. 1734 (valued at 180 ducats); this volume is the transcript from the catalogue formerly in the Branicki collection at Sucha, made for Andrzej Mniszech. A draft of the main catalogue (*Inventory 1793–95*) lists the painting (still no. 1734) and values it at 200 ducats.

30 *Inventory 1795*, no. 1734. Another version of the same catalogue is in the Ossolineum in Wrocław, Ms 5583/III.

31 For the most complete recent history of Poland, see Zamoyski 2009.

32 The *Inventory 1795*, no. 1734 is annotated: "Sa Maj. le garde selon Ses ordres donnés à Grodno 1795." A list of the 172 paintings (including *The Polish Rider*) that were to be taken to Grodno by order of the king is preserved in *List 1795*. *The Polish Rider* is described on fol. 332v.

33 *Letter Bacciarelli–Stanisław August, Jan. 16, 1796.*

34 *Inventory 1796*. The *Polish Rider* still appears as no. 1734.

35 *Inventory 1799*, 409, no. 1734.

36 The drawing is signed and dated: "NB [in monogram] 1803" and inscribed: "Lisowszik Cavalerie kosaque dont Wladislas IV avait envoyé douze milles . . . Maximillien Dessiné par Norblin d'aprés un Tableau de Rembrandt qui etait à Stanislas roy de Pologne." It last appeared for sale at Christie's, London, on July 3, 2012 (Sale 5688), no. 92.

37 Volume 2 of Waleria Tarnowska's journal covers the period from October 1, 1810, to November 7, 1811. "Cet appartement de Stanislas Auguste resté absolument dans le même état depuis son départ de sa Capitale pour Grodno, ce fauteuil, ce secrétaire, cet encrier, ces plumes, ces papiers épars, ce Calendrier ouvert de l'année 1794 tout cela fait mal, et l'on échappa avec plaisir à ces tristes souvenirs"; *Waleria Stroynowska Journal*, 502. Most printed sources referring to Waleria Tarnowska's diary (for example, Ciechanowiecki 1960, 296) mistakenly give the year of her visit to Łazienki as 1810.

38 "Dans la chambre de billard . . . entre-autres plusieurs bons Rembrandt—un Juif et sa fille, un Lisowczyk, que Jaś s'obstina à croire Stanislas Stroynowski—comme j'achèterais cela si j'étais en argent, car tout est à vendre dans ce beau et riche Lazienki"; *Waleria Stroynowska Journal*, 501.

39 Ciechanowiecki (1960, 296) correctly states that Waleria Stroynowska was the first to connect *The Polish Rider* with a member of the Lisowski regiment, but he mistakenly gives the year as 1810 instead of 1811.

40 "Vendu le 3 Juin 1814 au Pce Lubecki p. # 150 en ducats d'holen. De Napol par entremise de M. le Com. Sartorius" is annotated next to *The Polish Rider*'s entry in *Inventory 1795*, no. 1734. Held (1944, 249) reports the date incorrectly as June 13 instead of June 3.

41 The house at Horochów is now destroyed. For the house, see Aftanazy 1994, 125–30.

42 Dzieduszycki 1843a, 159; Prymak 2011, 162.

43 For Dzików and its collection, see Grottowa 1957; Janas and Wójcik 1994; Wójcik-Łużycki 2015; Zych 2016.

44 "Lisowczyk kupiony w Hollandyi przez Hr. Oginskiego do Galeryi Obrazow Stanisława Augusta, z kąd dostał się Xięciu Jozefowi Poniatowskiemu: w czasie zas licytacyi Obrazów z Łazienek–został ztamtąd nabyty p Biskupa Stroynowskiego za #500"; *Inventory ca. 1834*, 148. I would like to thank Michał Przygoda for his help in transcribing and translating the four Tarnowski inventories. The original Polish spelling of the inventories has been retained in the transcriptions notwithstanding its mistakes.

45 "Lisowczyk na koniu przez Rembrandta obraz duży na płótnie w ramie złotey nabyty przez Ogińskiego w Amzterdamie dla Króla Stanisława Augusta, a w Łazienkach nabyty przez Hrabie Stroynowskiego Biskupa Wileńskiego w Łazienkach za # 500" (Lisowczyk on horseback by Rembrandt large picture on canvas in a golden frame bought by Ogiński in Amsterdam for King Stanisław August, bought by Count Stroynowski Bishop of Wilno in Łazienki for # 500); *Inventory 1844*, 30.

46 Koźmian 1842, 27; Held 1944, 250.

47 Dzieduszycki 1843a, 159; Prymak 2011, 162.

48 "21. Lisowczyk. (Kupiony w Amsterdamie dla Stanisława Augusta przez hetm. Ogińskiego: następnie po śmierci króla [kupiony] przez ks.

Strojnowskiego bisk. Wileńskiego. Kupiony jako
Rembrandt" (21. Lisowczyk (Bought in
Amsterdam for Stanisław August by hetman
Ogiński: later after king's death [bought] by priest
Strojnowski bishop of Wilno. Bought as a
Rembrandt); *Inventory 1872*, 95. It appears again
in the same inventory: "21. Kupiony jako
Rembrandt. Lisowczyk. Kupiony w Amsterdamie
dla St. Augusta, po śmierci tego [kupiony] przez
ks. Stroynowskiego bisk. Wileńskiego" (21.
Bought as a Rembrandt. Lisowczyk. Bought in
Amsterdam for Stanisław August, after his death
[bought] by priest Stroynowski bishop of Wilno);
Inventory 1872, 99.

49 Bode 1883, 499.

50 Wurzbach (1906, 573) claims that *The Polish Rider*
was for sale in Vienna in 1877.

51 *Inventory before 1910*, 84.

52 Bredius 1897; Broos 1991, 52–53.

53 Broos 1991, 53.

54 The Stedelijk Museum had opened in 1895. For
the exhibition, see Amsterdam 1898; Nicolle
1898; Thiel 1992; Haskell 2000, 102–4.

55 "le beau cavalier de Rembrandt"; letter from
Abraham Bredius to Zdzisław Tarnowski, June 27,
1898, Art Collecting Files of Henry Clay Frick,
The Frick Collection/Frick Art Reference Library
Archives.

56 ". . . mais quelle surprise, quelle nouvelle
admiration pour le grand Maître quand votre
Magnifique tableau, presque inconnu se revèle là
dans toute sa beauté!"

57 "J'en suis prèsque sur, que Vous regretteriez plus
tard de ne pas avoir contribué à la réussite de cette
Exposition unique dans l'histoire de l'Art! Pensez
donc, près de 90 oeuvres réunis d'un des plus
grand artistes du monde! Tous les frais sont pour la
Commission; le danger est évité de toutes
manières, le Musée est un bel édifice nouveau qui
donne toutes les guaranties contre vol et incendie.
Cette Exposition sera l'Apothéose de Votre
tableau—il sera Classé désormais, Classé parmi les
Chef-d'oeuvres de notre Grand Maître."

58 "Je comprends, que Vous avez peur de le Confier a
des mains étrangères, mais la caisse de Hauser sera
bonne et des mains qu'on l'ouvre en Hollande, ce
ne seront que des mains pieuses qui manieront le
tableau . . . Et comme ce bijou est gardé dans un
écrin bien à l'abri des curieux, dans un coin du
monde pas facilment abordable, Vous ferez un
grand bien fait en montrant une fois ce joyau au
grand jour—pour deux mois seulement!"

59 "Rendez nous heureux! Nous serons
reconnaissants! Et venez voir, avec Madame la
Comtesse cette Exposition intéressante qui Vous
permettra de jeter un coup d'oeil sur ce petit pays
curieux qu'on appelle les Pays Bas."

60 "Portrait d'un cavalier polonais, portant l'uniforme
du régiment de Lysowsky, dans un paysage";
Amsterdam 1898, no. 94.

61 "très peu connu jusqu'à ces derniers temps . . . l'un
des plus remarqués de l'exposition"; Nicolle 1898,
558.

62 Brinton 1900.

63 Cable from Roger Fry to Henry Clay Frick,
April 15, 1910, Art Collecting Files of Henry Clay
Frick, The Frick Collection/Frick Art Reference
Library Archives. For Frick's purchase of *The Polish
Rider*, see Esmée Quodbach in New York 2011,
17–18.

64 "by all accounts condition excellent picture never
removed from owners chateau since amsterdam
exhibition unfortunately no time visit it there
before eighteenth but you could make purchase
conditional on my approval of condition am in
direct communication owners brother hope you
will not miss this superb work"; cable from Roger
Fry to Henry Clay Frick, April 16, 1910, Art
Collecting Files of Henry Clay Frick, The Frick
Collection/Frick Art Reference Library Archives.

65 Ibid.

66 Letter from Roger Fry to Henry Clay Frick,
April 24, 1910 Art Collecting Files of Henry Clay
Frick, The Frick Collection/Frick Art Reference
Library Archives.

67 Cable from Roger Fry to Henry Clay Frick,
April 19, 1910, Art Collecting Files of Henry Clay

68 Frick, The Frick Collection/Frick Art Reference Library Archives.

68 Cable from Roger Fry to Henry Clay Frick, April 20, 1910, Art Collecting Files of Henry Clay Frick, The Frick Collection/Frick Art Reference Library Archives.

69 Ibid.

70 Fry 1972, 330.

71 Batowski 1910; Prymak 2011, 164.

72 Fry 1972, 331.

73 Cable from Roger Fry to Henry Clay Frick, May 3, 1910, Art Collecting Files of Henry Clay Frick, The Frick Collection/Frick Art Reference Library Archives.

74 Letter from Henry Clay Frick to Ronald Knoedler, May 13, 1910, Art Collecting Files of Henry Clay Frick, The Frick Collection/Frick Art Reference Library Archives.

75 "la copie de 'Lisowozyk,' car vraiment elle est remarquablement belle"; letter from Zdzisław Tarnowski to Roger Fry, January 22, 1911, Art Collecting Files of Henry Clay Frick, The Frick Collection/Frick Art Reference Library Archives.

76 Cable from Roger Fry to Henry Clay Frick, May 9, 1910, Art Collecting Files of Henry Clay Frick, The Frick Collection/Frick Art Reference Library Archives.

77 Cable from Roger Fry to Henry Clay Frick, June 17, 1910, Art Collecting Files of Henry Clay Frick, The Frick Collection/Frick Art Reference Library Archives.

78 I would like to thank Michał Przygoda for this information, which derives from his systematic study of frames in Polish collections.

79 Cable from Henry Clay Frick to Roger Fry, July 22, 1910, Art Collecting Files of Henry Clay Frick, The Frick Collection/Frick Art Reference Library Archives.

80 Receipt and payments for Frick's acquisition of The Polish Rider are preserved in the Acquisition File for Rembrandt's Polish Rider, 1910–1913, Art Collecting Files of Henry Clay Frick, The Frick Collection/Frick Art Reference Library Archives.

81 Sanger 1998, 73–74.

82 Ibid., 452.

83 Sanger (1998, 452) mistakenly dated the photograph to 1909 and illustrated it in reverse (without stating it) to strengthen her point.

84 Vienna was effectively the capital of this part of Poland, and the Tarnowski kept a house there. The reason for The Polish Rider being sent to Vienna around 1833 and 1877 and for Zdzisław Tarnowski later asking for Frick's payment to be transferred to a bank in Vienna was that the city was effectively the main point of political reference for them at the time.

85 This account of the principal reason behind the sale of The Polish Rider derives from the recollections of Artur Tarnowski, Zdzisław's son. They were published in Janas and Wójcik 1994. I would like to thank Andrew Tarnowski for providing me with this and many other useful pieces of information on his family. For a later history of the Tarnowski, see Tarnowski 2006.

86 Fry 1972, 331.

87 Dzieduszycki 1843a; Dzieduszycki 1843b.

88 The image was published in Tygodnika Illustrowany, vol. 10, 1859, p. 77.

89 "While we agree . . . that the costume was not unlike a Polish one of the seventeenth century, we must maintain that there is no part of it which was worn only in Poland and not also in some adjoining countries, especially in Hungary. . . . One cannot help suspecting that the painting, had it been found by accident in a Hungarian castle instead of a Polish one, might have become famous, with equal if not better right, as the 'Hungarian' Rider"; Held 1944, 255.

90 Żygulski 1965; Żygulski 1999; Żygulski 2000; Żygulski 2008.

91 Held 1944, 253–54; Żygulski 1965, 60–61, 63.

92 Żygulski 1965, 56–57.

93 Ibid., 65.

94 Ibid., 64.

95 Held 1944, 254–55; Żygulski 1965, 53, 55–56, 65–66.

96 For the scroll, see Anna Kuśmidrowicz-Król in Ostrowski 1999, 102–5, no. 1; Zdańkowska 2019.

97 For Polish costume and the East, see Żygulski 1999; Jasienski 2014. "By the early 1600s the Polish cavalry had adopted most of the weapons used by the Turks as well as many of their tactics. The hetmans used the Turkish baton of command, and the horse-tails which denoted rank among the Turks were borne aloft behind them too. The Poles also dressed more and more like their foe, and even the Tatar habit of shaving the head was widely practiced on campaign. . . . This 'Sarmatian' costume became a symbol of healthy, straightforward patriotic Polishness, while French or German clothes were equated with foreign intrigue"; Zamoyski 2009, 170–71.

98 Jasienski 2014, 176, 186.

99 Zamoyski 2009, 94, 95, 105, 175.

100 "Polish diplomatic missions were notorious throughout seventeenth-century Europe for their splendour"; Zamoyski 2009, 152.

101 Jasienski 2014, 173.

102 A drawing of the *Entry of the Polish Ambassador Krzysztof Opaliński into Paris* of 1645 by Della Bella is in the British Museum, London (1895,0617.396); Held 1944, 256–58.

103 Held 1944, 258. For Della Bella's etching of Poles, see Massar 1968, 176.

104 For Rembrandt and costume, see Winkel 2006.

105 Held 1944, 255. "In these years he is like a child finding a trunk of old clothes in the attic, and pulling out of it all the richest material it contains. He dressed up Saskia in these improbable garments, and painted her as Flora or Persephone. And he put on fancy dress himself; in fact he had been doing so ever since he had come to Amsterdam"; Clark 1978, 18.

106 The inventory is transcribed in Schwartz 1895, 288–91.

107 Nadler 2003.

108 For Rembrandt's copies of Indian drawings, see Los Angeles 2018; Robinson 2018.

109 Held 1944, 259.

110 Broos 1974, 207–13; Thijssen 1992.

111 Białostocki 1969, 169.

112 Sickert 1947, 161. Żygulski (1965, 56) understandably rejected the proposal, which was first made in 1904 by Mycielski.

113 Broos 1974, 207–13; Chrościcki 1981; Prymak 2011.

114 For this theory, see Białostocki 1969; Bailey 1978, 129–31.

115 For the painting, see Amsterdam 2017, 78, 154–56. For its connection to *The Polish Rider*, see Held 1944, 252; Colin B. Bailey in New York 2011, 42.

116 Held 1944, 251–52.

117 Held 1944, 259–63; Clark 1966, 37; Clark 1978, 59.

118 For Gysbrecht van Aemstel, see Valentiner 1948. For Tamerlane, see Schwartz 1985, 277–78.

119 Kannegieter 1970.

120 Clark 1978, 60.

121 For the Wandering Jew, see Gimpel 1966, 96. For David, see Slatkes 1983, 60–92. For Esau, see Valentiner 1948, 130. For the Prodigal Son, see Campbell 1970; Campbell 1973. For Nimrod, see Cómez Ramos 2000.

122 Held 1944, 246. This idea was also supported by Davidson 1968, 262.

123 Held 1991, 199.

124 Munhall 1970, 74; Colin B. Bailey in New York 2011, 39.

125 Clark 1978, 32.

BIBLIOGRAPHY

Abbreviations

AGAD – Archiwum Główne Akt Dawnych [Central Archives of Historical Records], Warsaw

ANK – Archiwum Narodowe w Krakowie [National Archives], Kraków

TAD – Tarnowski Family Archive, Dzików

MANUSCRIPT SOURCES

Inventory 1784–92 *Classe des Sujets du Catalogue des Tableaux du Roi en 1784.* AGAD, Archiwum księcia Józefa Poniatowskiego i Marii Teresy Tyszkiewiczowej [Prince Józef Poniatowski and Maria Teresa Tyszkiewicz Archive], 201.

Inventory 1793 *Catalogue des Tableaux appartenant à Sa Maj[esté] le Roi de Pologne 1793.* Bibliothèque d'Art et d'Archéologie, Paris, Ms. 12.

Inventory 1793–95 Draft of *Catalogue des Tableaux appartenant à Sa Maj[esté] le Roi de Pologne 1793* [title page missing]. AGAD, Komisja Nadzoru Budowli Korony [Superintendency of Royal Buildings], 168.

Inventory 1795 *Catalogue des Tableaux appartenant à Sa Maj[esté] le Roi de Pologne 1795.* AGAD, Archiwum księcia Józefa Poniatowskiego i Marii Teresy Tyszkiewiczowej [Prince Józef Poniatowski and Maria Teresa Tyszkiewicz Archive], 202.

Inventory 1796 *Inventaire des 13 caisses où on a emballè les Miniatures, Portraits en Pastel, Portraits à l'huile, Tableaux et dessins . . . le 11 Mars 1796.* AGAD, Korespondencja Stanisława Augusta [Correspondence of King Stanisław August], 5b, 42 ff.

Inventory 1799 *Inventarium des Nachlasses des, den 11 Februarii 1797 in Petersbourg vestorben Königs von Pohlen Stanislaus Augustus, verfertiget den 18 November 1799 von dem Fürsten Joseph Poniatowski als Beneficial Erben.* AGAD, Archiwum księcia Józefa Poniatowskiego i Marii Teresy Tyszkiewiczowej [Prince Józef Poniatowski and Maria Teresa Tyszkiewicz Archive], 118.

Inventory ca. 1834 *Regestr rzeczy moich i sprzętów Domowych* [*Inventory of my belongings and homeware*]. ANK, Archiwum Dzikowskie Tarnowskich [The Dzików Archives of the Tarnowski], ADzT 311.

Inventory 1844 *Opisanie Pokoi i Opisanie Pokoi i szczegółowo w nich zawartych rzeźb, obrazów, marmurów, mebli i innych sprzętów domowych znajdujących się w Zamku Dzikowskim pod dniem 1wszym Grudnia 1844 ułożone* [*Description of rooms and sculptures, paintings, marbles, furniture and other household objects kept in Dzików*

Castle drawn up on the 1st of December 1844]. ANK, Archiwum Dzikowskie Tarnowskich [The Dzików Archives of the Tarnowski], ADzT 333.

Inventory 1872 *Spis dzieł sztuki w zamku Jaśnie Wielmożnych Tarnowskich w Dzikowie się znajdujących / r. 1872 ułożony* [*List of artworks kept in the castle of the honorable Tarnowskis in Dzików / drawn up in 1872*]. ANK, Archiwum Dzikowskie Tarnowskich [The Dzików Archives of the Tarnowski], ADzT 333.

Inventory before 1910 *Zamek. Spisy i inwentarze urządzenia wewn., dzieł sztuki, garderoby Jaśnie Wielmożnego Właściciela I t.p.* [*The Castle. Lists and inventories of house furnishings, artworks, wardrobe of the Honorable Owner etc.*]. ANK, Archiwum Dzikowskie Tarnowskich [The Dzików Archives of the Tarnowski], ADzT 877.

Letter Bacciarelli–Stanisław August, Jan. 16, 1796 Letter from Marcello Bacciarelli to Stanisław August of January 16, 1796. AGAD, Korespondencja Stanisława Augusta [Correspondence of King Stanisław August], 5b, 18 ff.

List 1795 *Catalogue des Tableaux du Roy* [1795]. AGAD, Korespondencja Stanisława Augusta [Correspondence of King Stanisław August], 5a, 331 ff.

Waleria Stroynowska Journal Stroynowska, Waleria. *Mon Journal*, vol. 2 (1810–11). TAD, 219. Przyb. 113/52.

PRINTED SOURCES

Aftanazy 1994 Aftanazy, Roman. *Dzieje rezydencji na dawnych kresach Rzeczypospolitej.* Vol. 5. Wrocław, 1994.

Amsterdam 1898 *Rembrandt: Collection des œuvres du maître réunies, à l'occasion de l'inauguration de S.M. la Reine Wilhelmine.* Exh. cat. Amsterdam (Rijksmuseum), 1898.

Amsterdam 2017 Norbert Middelkoop. *Ferdinand Bol and Govert Flinck: Rembrandt's Master Pupils.* Exh. cat. Amsterdam (The Rembrandt House Museum and the Amsterdam Museum), 2017.

Bailey 1978 Bailey, Anthony. *Rembrandt's House.* Boston, 1978.

Bailey 1990 Bailey, Anthony. "A Young Man on Horseback." *New Yorker*, March 5, 1990, 45–76.

Bailey 1994 Bailey, Anthony. *Responses to Rembrandt: Who Painted the Polish Rider? A Controversy Considered.* New York, 1994.

Batowski 1910 Batowski, Zygmunt. "Z powodu sprzedaży Lisowczyka." *Lamus* 3 (1910): 189–96.

Białostocki 1969 Białostocki, Jan. "Rembrandt's 'Eques Polonus.'" *Oud Holland* 84 (1969): 163–76.

Bikker 2005 Bikker, Jonathan. *Willem Drost (1633–1659): A Rembrandt Pupil in Amsterdam and Venice.* New Haven and London, 2005.

Bikker 2013 Bikker, Jonathan. *The Night Watch.* Amsterdam, 2013.

Bode 1883 Bode, Wilhelm von. *Studien zur Geschichte der holländischen Malerei.* Berlin, 1883.

Bredius 1897 Bredius, Abraham. "Onbekende Rembrandts in Polen, Galicie en Rusland." *De nederlandsche spectator* 1897: 197–99.

Bredius 1969 Bredius, Abraham. *Rembrandt: The Complete Edition of the Paintings.* Revised by Horst Gerson. London, 1969.

Brinton 1900 Brinton, Christian. "New Light on Rembrandt." *New York Times*, March 3, 1900.

Broos 1974 Broos, B. P. J. "Rembrandt's Portrait of a Pole on His Horse." *Simiolus: Netherlands Quarterly for the History of Art* 7 (1974): 192–218.

Broos 1991 Broos, Ben. "Het mysterie van De Poolse ruiter." *Vrij Nederland* 49 (December 7, 1991): 52–56.

Bruyn 1984 Bruyn, Josua. "Review of *Gemälde Rembrandt-Schüler, I* by W. Sumowski." *Oud Holland* 98 (1984): 146–62.

Campbell 1970 Campbell, Colin. "Rembrandt's 'Polish Rider' and the Prodigal Son." *Journal of the Warburg and Courtauld Institutes* 33 (1970): 292–303.

Campbell 1973 Campbell, Colin. "The Identity of Rembrandt's 'Polish Rider.'" In *Neue Beiträge zur Rembrandt-Forschung*, edited by Otto V. Simson and Jan Kelch, 126–37. Berlin, 1973.

Chrościcki 1981 Chrościcki, Juliusz A. "Rembrandt's Polish Rider: Allegory or Portrait?" In *Ars Auro Prior: Studia Ioanni Białostocki Sexagenario Dicata*, by William S. Heckscher et al., 441–47. Warsaw, 1981.

Ciechanowiecki 1960 Ciechanowiecki, Andrew. "Notes on the Ownership of Rembrandt's Polish Rider." *Art Bulletin* 42 (1960): 294–96.

Clark 1966 Clark, Kenneth. *Rembrandt and the Italian Renaissance.* New York, 1966.

Clark 1978 Clark, Kenneth. *An Introduction to Rembrandt.* London, 1978.

Cómez Ramos 2000 Cómez Ramos, Rafael. "El 'Ex-Jinete Polaco' de Rembrandt: una nueva lectura." *Laboratorio de Arte* 12 (2000): 135–42.

Davidson 1968 Davidson, Bernice, ed. *The Frick Collection: An Illustrated Catalogue. Volume I: Paintings. American, British, Dutch, Flemish and German*. New York, 1968.

Dzieduszycki 1843a Dzieduszycki, Maurycy. "Wizerunek Lisowczyka, obraz olenjy Rembrandta." *Biblioteka Naukowego Zakladu imienia Ossolińskich* 8 (1843): 157–59.

Dzieduszycki 1843b Dzieduszycki, Maurycy. *Krótky rys dziejów i sparw lisowczyków*. Vol. 1. Lwów, 1843.

Ford 2007 Ford, Charles, ed. *Lives of Rembrandt: Sandrart, Baldinucci and Houbraken*. London, 2007.

Fry 1972 Fry, Roger. *The Letters of Roger Fry: Volume One*. Edited by Denys Sutton. London, 1972.

Gimpel 1966 Gimpel, René. *Diary of an Art Dealer*. New York, 1966.

Grottowa 1957 Grottowa, Kazimiera. *Zbiory Sztuki Jana Feliksa i Walerii Tarnowskich w Dzikowie (1803–1849)*. Wrocław, 1957.

Haskell 2000 Haskell, Francis. *The Ephemeral Museum: Old Master Paintings and the Rise of the Art Exhibition*. New Haven and London, 2000.

Held 1944 Held, Julius S. "Rembrandt's 'Polish' Rider." *Art Bulletin* 26 (1944): 246–65.

Held 1969 Held, Julius S. "The 'Polish' Rider." In *Rembrandt's "Aristotle" and Other Studies*, 45–84. Princeton, 1969.

Held 1991 Held, Julius S. *Rembrandt Studies*. 2nd edition. Princeton, 1991.

Janas and Wójcik 1994 Janas, Aleksandra, and Adam Wójcik. *Zamek Tarnowskich w Dzikowie*. Warsaw, 1994.

Jasienski 2014 Jasienski, Adam. "A Savage Magnificence: Ottomanizing Fashion and the Politics of Display in Early Modern East-Central Europe." *Muqarnas* 31 (2014): 173–205.

Juszczak and Małachowicz 2016 Juszczak, Dorota, and Hanna Małachowicz. *The Stanisław August Collection of Paintings at the Royal Łazienki: Catalogue*. Warsaw, 2016.

Kannegieter 1970 Kannegieter, J. Z. "De Poolse Ruiter." *Kroniek van het Rembrandthuis* 24 (1970): 85–88.

Kitson 1982 Kitson, Michael. *Rembrandt*. Oxford, 1982.

Koźmian 1842 Koźmian, Kajetan. *Rys Życia Jana Felika Hrabiego Tarnowskiego*. Lwów, 1842.

London 2009 Ian A. C. Dejardin, ed. *Dulwich Picture Gallery: The Polish Connection*. Exh. cat. London (Dulwich Picture Gallery), 2009.

Los Angeles 2018 Stephanie Schrader, ed. *Rembrandt and the Inspiration of India*. Exh. cat. Los Angeles (The J. Paul Getty Museum), 2018.

Mańkowski 1929 Mańkowski, Tadeusz. *Obrazy Rembrandta w galerji Stanisława Augusta*. Kraków, 1929.

Martineau 2016 Martineau, Paul, ed. *The Thrill of the Chase: The Wagstaff Collection of Photographs at the J. Paul Getty Museum*. Los Angeles, 2016.

Massar 1968 Massar, Phyllis D. "Presenting Stefano della Bella." *Metropolitan Museum of Art Bulletin* 27 (1968): 159–76.

Munhall 1970 Munhall, Edgar. *Masterpieces of The Frick Collection*. New York, 1970.

Nadler 2003 Nadler, Steven. *Rembrandt's Jews*. Chicago and London, 2003.

New York 2011 Colin B. Bailey et al. *Rembrandt and His School: Masterworks from the Frick and Lugt Collections*. Exh. cat. New York (The Frick Collection), 2011.

Nicolle 1898 Nicolle, Marcel. "L'exposition Rembrandt à Amsterdam II." *La Revue de l'art ancien et moderne* 4 (1898): 541–58.

O'Hara 1971 O'Hara, Frank. *The Collected Poems of Frank O'Hara*. Edited by Donald Allen. New York, 1971.

Ostrowski 1999 Ostrowski, Jan K., ed. *Land of the Winged Horsemen: Art in Poland 1572–1764*. Alexandria, Va., 1999.

Prymak 2011 Prymak, Thomas M. "Rembrandt's 'Polish Rider' in Its East European Context." *Polish Review* 56 (2011): 159–86.

Robinson 2018 Robinson, William W. *Rembrandt's "Indian Drawings" and His Later Work*. New York, 2018.

Sanger 1998 Sanger, Martha Frick Symington. *Henry Clay Frick*. New York, London, and Paris, 1998.

Schama 1999 Schama, Simon. *Rembrandt's Eyes*. London, 1999.

Schwartz 1985 Schwartz, Gary. *Rembrandt: His Life, His Paintings*. New York, 1985.

Sickert 1947 Sickert, Walter Richard. *A Free House! Or The Artist as Craftsman*. Edited by Osbert Sitwell. London, 1947.

Silver 2018 Silver, Larry. *Rembrandt's Holland*. London, 2018.

Slatkes 1983 Slatkes, Leonard J. *Rembrandt and Persia*. New York, 1983.

Tarnowski 2006 Tarnowski, Andrew. *The Last Mazurka: A Family's Tale of War, Passion, and Loss*. New York, 2006.

Thiel 1992 Thiel, P. J. J. van. "De Rembrandt-tentoonstelling van 1898." *Bulletin van het Rijksmuseum* 40 (1992): 11–93.

Thijssen 1992 Thijssen, Lucia. *1000 jaar Polen en Nederland*. Zutphen, 1992.

Valentiner 1931 Valentiner, Wilhelm R. *Rembrandt Paintings in America*. New York, 1931.

Valentiner 1948 Valentiner, Wilhelm R. "Rembrandt's Conception of Historical Portraiture." *Art Quarterly* 11 (1948): 117–35.

Verschoor 2018 Verschoor, Gerdien. "'These Things Are Immortal.' The Wanderings of Rembrandt's *Polish Rider*." *The Low Countries: Arts and Society in Flanders and the Netherlands* 26 (2018): 88–97.

Van de Wetering 2009 Van de Wetering, Ernst. *Rembrandt: The Painter at Work*. Amsterdam, 2009.

Van de Wetering 2011 Van de Wetering, Ernst, ed. *Rembrandt Research Project: A Corpus of Rembrandt Paintings. V. Small-Scale History Paintings*. Dordrecht, 2011.

Van de Wetering 2014 Van de Wetering, Ernst, ed. *Rembrandt Research Project: A Corpus of Rembrandt Paintings. VI. Rembrandt's Paintings Revisited*. Dordrecht, 2014.

Winkel 2006 Winkel, Marieke, de. *Fashion and Fancy: Dress and Meaning in Rembrandt's Paintings*. Amsterdam, 2006.

Wójcik-Łużycki 2015 Wójcik-Łużycki, Adam. *Muzeum—Zamek Tarnowskich w Dzikowie: Przewodnik*. Tarnobrzeg, 2015.

Wurzbach 1906 Wurzbach, Alfred von. *Niederländisches Künstler-Lexikon*. Vienna and Leipzig, 1906.

Yourcenar 1957 Yourcenar, Marguerite. *Coup de Grâce*. New York, 1957.

Zamoyski 1992 Zamoyski, Adam. *The Last King of Poland*. London, 1992.

Zamoyski 2009 Zamoyski, Adam. *Poland: A History*. London, 2009.

Zdańkowska 2019 Zdańkowska, Marta. *The Stockholm Scroll: A Treasure of the Royal Castle in Warsaw*. Warsaw, 2019.

Zych 2016 Zych, Tadeusz. *Kolekcja Dzikowska: Zbiory Hrabiów Tarnowskich*. Tarnobrzeg, 2016.

Żygulski 1965 Żygulski, Zdzisław. "Rembrandt's 'Lisowczyk': A Study of Costume and Weapons." *Bulletin du Musée National de Varsovie* 6 (1965): 43–67.

Żygulski 1999 Żygulski, Zdzisław. "The Impact of the Orient on the Culture of Old Poland." In *Land of the Winged Horsemen: Art in Poland 1572–1764*, edited by Jan K. Ostrowski, 69–79. Alexandria, Va., 1999.

Żygulski 2000 Żygulski, Zdzisław. "Further Battles for the 'Lisowczyk' (Polish Rider) by Rembrandt." *Artibus et Historiae* 21 (2000): 197–205.

Żygulski 2008 Żygulski, Zdzisław. "O Amerykańskich Polonikach Rembrandta, czyli bajka o perle i bucie." *Rocznik Historii Sztuki* 33 (2008): 45–51.

INDEX

Page numbers in *italics* refer to the illustrations.

PHOTOGRAPHY CREDITS

Photographs in this book have been provided by the owners or custodians of the works. The following list applies to those photographs for which a separate credit is due.